# MASTERING
# COMPOSITION
# AND LIGHT

# MASTERING
# COMPOSITION
# AND LIGHT

Published by Time-Life Books in association with Kodak

# MASTERING COMPOSITION AND LIGHT

Created and designed by Mitchell Beazley International
in association with Kodak and TIME-LIFE BOOKS

**Editor-in-Chief**
Jack Tresidder

**Series Editor**
John Roberts

**Art Editor**
Mel Petersen

**Editors**
Ian Chilvers
Louise Earwaker
Richard Platt

**Designers**
Robert Lamb
Michelle Stamp
Lisa Tai

**Assistant Designer**
Susan Rentoul

**Picture Researchers**
Brigitte Arora
Nicky Hughes
Beverly Tunbridge

**Editorial Assistant**
Margaret Little

**Production**
Peter Phillips
Jean Rigby

**Consultant Photographer**
Michael Busselle

**Coordinating Editors for Kodak**
Kenneth Lassiter
Kenneth Oberg
Jacalyn Salitan

**Consulting Editor for Time-Life Books**
Thomas Dickey

Published in the United States
and Canada by TIME-LIFE BOOKS

**President**
Reginald K. Brack Jr.

**Editor**
George Constable

The KODAK Library of Creative Photography
© Kodak Limited All rights reserved

Mastering Composition and Light
© Kodak Limited, Mitchell Beazley Publishers,
Salvat Editores, S.A., 1983

Library of Congress catalog card number 82-629-76
ISBN 0-86706-209-6
LSB 73 20L 04
ISBN 0-86706-211-8 (retail)

# Contents

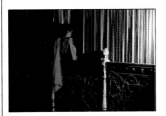
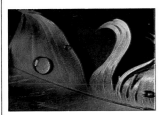
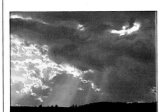
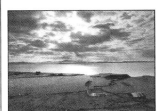

# WHAT MAKES A GOOD PICTURE ?

Responding to pictures is largely a matter of personal taste. The elements of a photograph somehow combine and strike a chord for one person, while for another the image may mean little. Yet some pictures, such as the haunting one on the opposite page, have a quality that everyone can recognize and appreciate.

Apart from a subject's inherent interest, two things are fundamentally important in a picture: composition and light. The photographer of the picture opposite used a pattern of strong sunlight and deep shadows as the basis for a composition that has atmosphere and also looks just right visually. One of the picture's many virtues is its sense of depth – carrying the eye inward, as if through a sunlit window. But depth or perspective is only one of the important elements of composition. The pictures on the following nine pages exemplify others – balance and asymmetry, shape and form, pattern and texture. The book shows you how you can turn these seemingly abstract terms into practical ways of improving your pictures. They are at the core of creative photography. And by first following some basic rules in a systematic way, you can learn to recognize and use these pictorial elements instinctively. Light itself is fundamental to all the elements, and thus has a section of its own within this book. In a sense, light makes photographs; photographers only take them.

*Expert handling of light created this powerful image of a child playing in a sunbaked landscape at La Mancha, Spain, with the still figure of her grandmother silhouetted in a doorway. A shadowy foreground and a shaft of soft sunlight falling on the door balance the square of intense light that takes the eye into the middle distance and background.*

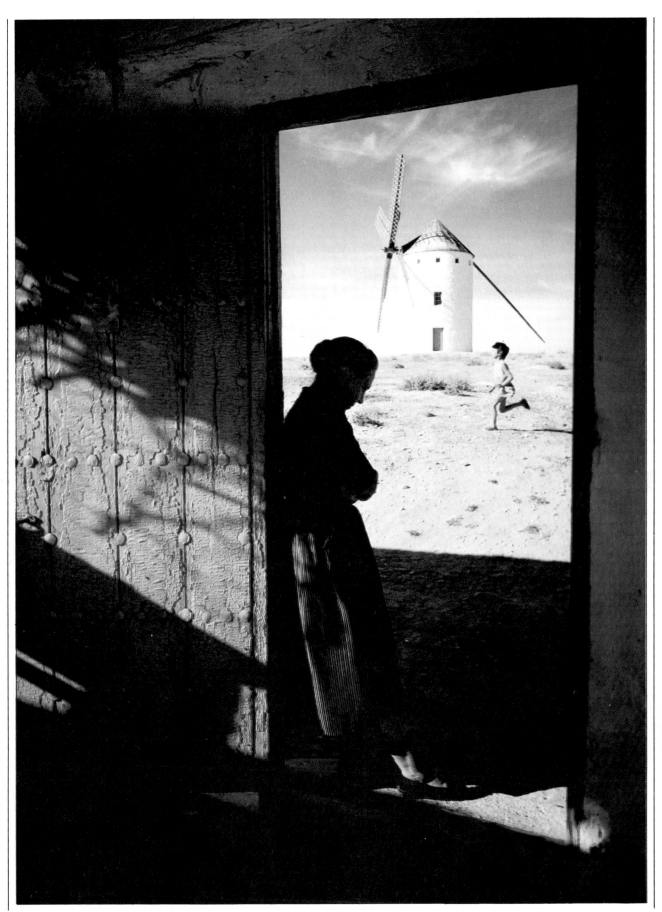

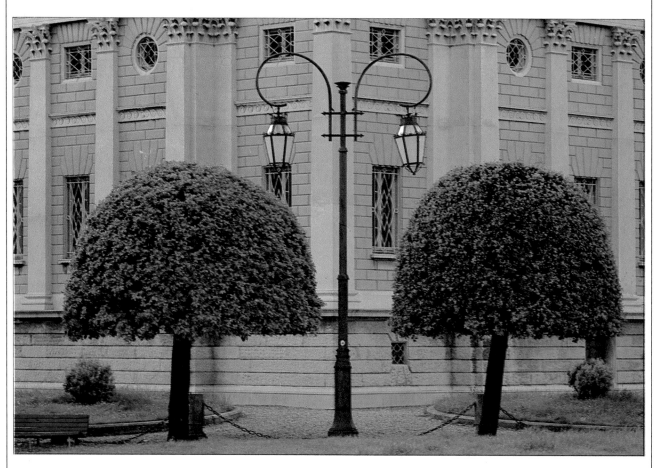

***Perfect balance*** *gives
this architectural view
a sense of calm elegance.
The photographer carefully
exploited the symmetry of
the paired trees, branched
lamp and pilasters behind.*

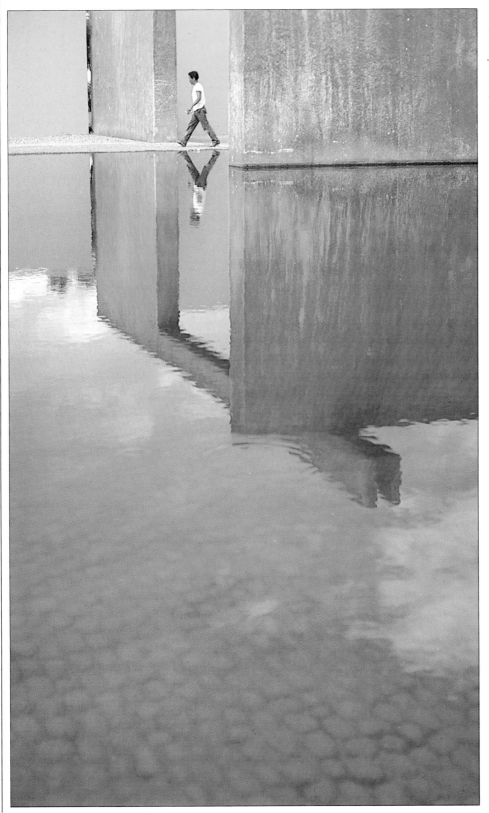

**Deliberate asymmetry** here establishes an unsettled mood. The lonely figure, framed so that he crosses the very top of the picture, emphasizes the emptiness of a concrete landscape.

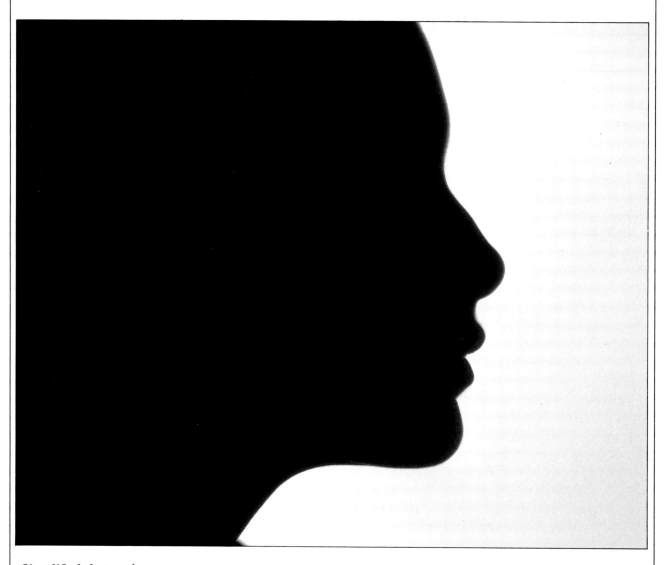

***Simplified shape*** – *the flowing outline of a girl's profile silhouetted against a light background – is the only element in this highly graphic image. Backlighting deliberately excludes every surface detail.*

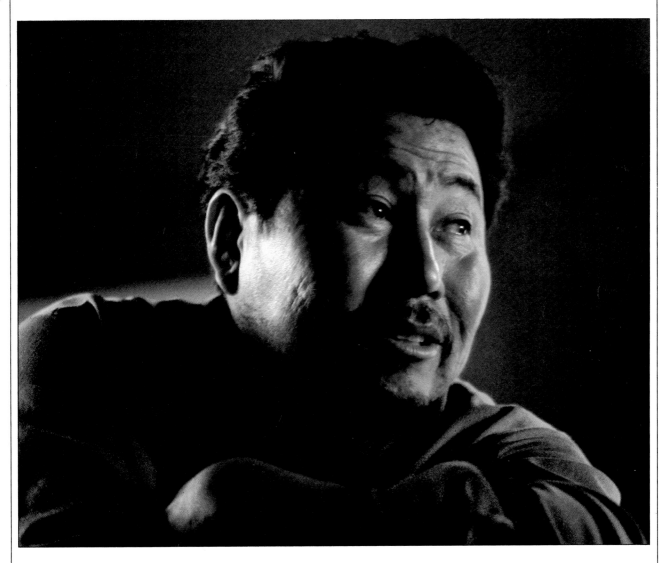

**Strong modeling of form**
*was needed in this picture to
bring out the expressive force
of a Kickapoo Indian's face.
The photographer used light
from windows on two sides
of a small room to carve
the man's chunky features.*

**Bold pattern** *creates visual unity in a picture of men working on a construction site. The photographer lined up the camera so that the grid of the steel structure corresponded perfectly with the edges of the picture.*

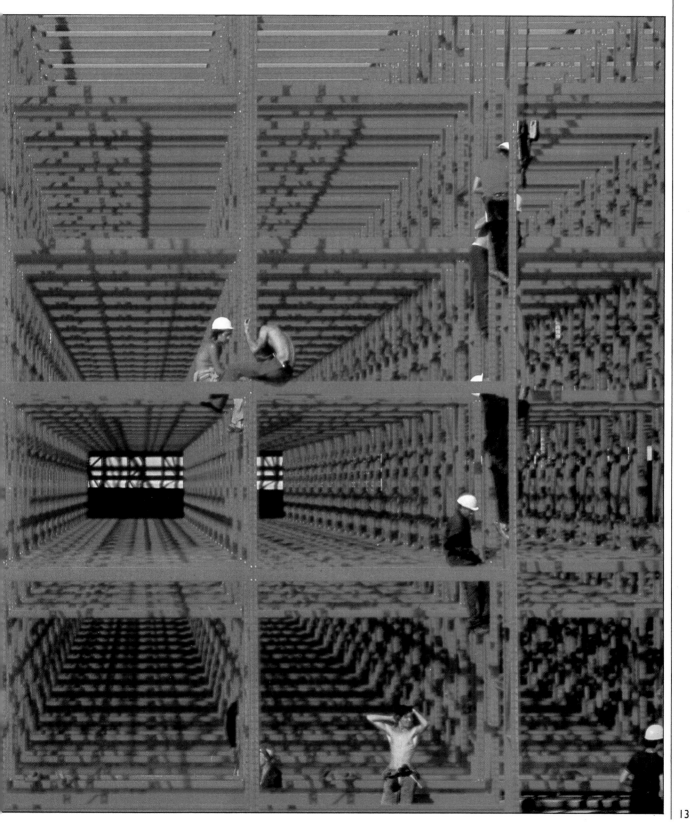

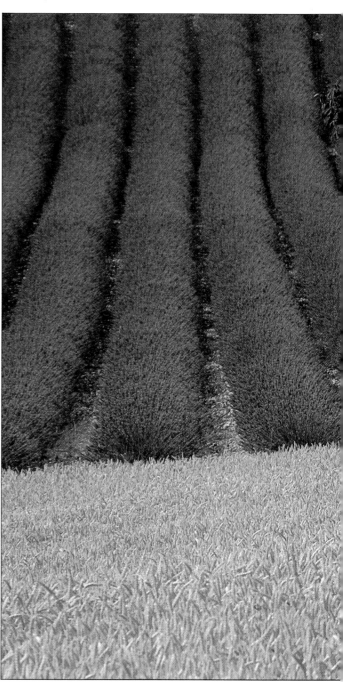

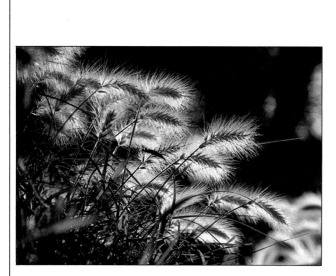

**The feathery look** of these wild grasses provides a textural quality that is the key to the success of the image. The photographer emphasized the delicacy of the seed heads by moving to place the light behind them.

**Pattern and texture** work together in this beautiful landscape. Use of a slow film has contributed to the sharply detailed effect that makes the rows of lavender look almost like skeins of wool softly looping upward.

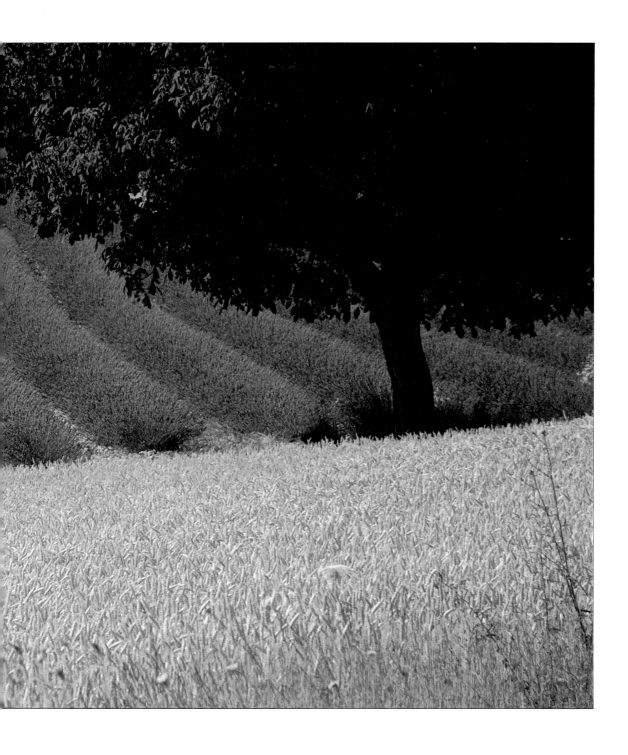

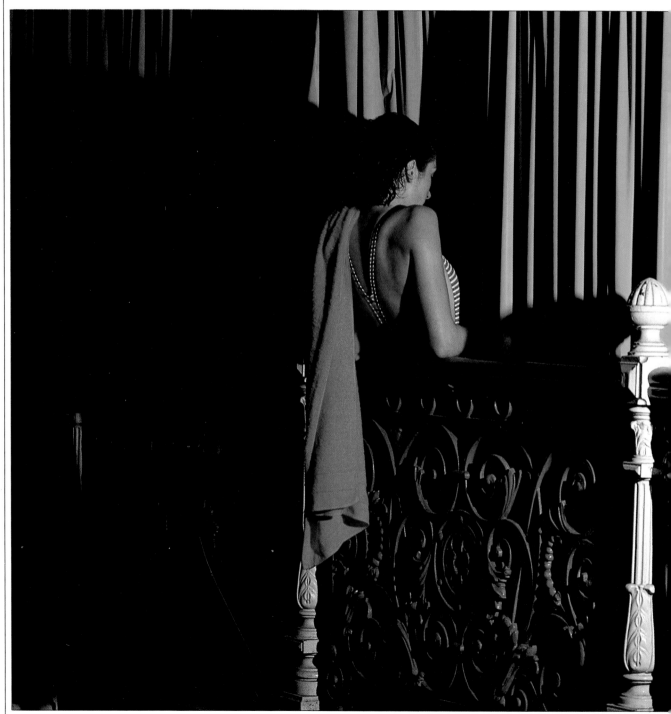

# BUILDING
# THE PICTURE

The speed and ease of pressing the shutter release on a modern camera can be a stumbling block to imaginative photography unless you recognize that most of the work involved in creating a picture should be done beforehand. You can produce effective images unerringly, rather than by chance, by applying principles of composition that depend on close observation of the subject in the viewfinder. Although these principles necessarily relate more to still subjects than to action pictures, they can help all aspects of your photography.

Whenever you plan a photograph, look long and hard at the subject until you are aware of every single aspect and detail. Then analyze what you see. Decide on the strongest point of interest, the aspect of the scene that first caught your attention. How can you make this feature prominent? Which other elements support the main feature, and where should they be placed to balance or add drama to the picture as a whole?

The following section of this book shows you, step by step, how to organize and manipulate the elements in a picture. Using these techniques, composition can become first a logical and controlled process, and eventually a natural way of seeing better pictures.

*The red towel, seemingly draped so casually across the girl's shoulder, was the photographer's bold final touch to a picture in which the effect of every element was calculated before the shutter clicked.*

# Ways of seeing

Ask a number of people to describe the same scene and you will get a different response from each of them. Similarly, a group of photographers asked to take pictures of the same subject will produce very different images. Four of the pictures on these pages, taken in New York, amply illustrate the point. One photographer was attracted by the scale and drama of lighted buildings at the city's heart at nightfall; another chose a commanding overview centered upon a familiar landmark; a third created a graphic image of the same landmark, looking upward from the street; and a fourth focused on life as it is lived at street level. In each case, the photographer's imagination was fired by a different aspect of the subject, yet all of the pictures, in their own individual ways, clearly say New York.

Of course, with a subject that offers such tremendous photographic scope as a great city does, it would be surprising had the photographers' choices of images coincided. But differences of image selection and approach also emerge in photographic situations that are much narrower in scope. Everybody has a personal way of seeing. And while a camera may seem to record the world objectively, the photographer always subjectively decides where the camera will look.

Being aware of your subjective reactions to a scene can help you to compose better photographs. Before you begin to set up a picture, try to decide what stimulated your interest in a scene. When you know why you want to take a photograph, you can go on to analyze the pictorial elements in the subject and decide the best way to portray them. Sometimes there may be a conflict of interest, as in the example at left below. The photographer's desire to get a picture of his companion and of an interesting building resulted in unsatisfactory images of both. By concentrating on one subject at a time, the photographer was able to find a better approach for each and a more effective picture as a result.

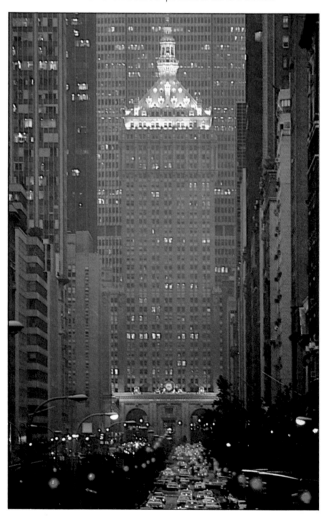

### Singling out a subject
The three photographs below, taken at London's Kew Gardens, show the importance of selecting only one dominant subject. At left, the foreground figure competes for attention with the greenhouses behind. The closer view makes the figure the main subject; the distant view does full justice to the scenery.

*The panoramic view* below, taken looking toward New York's Empire State Building with a 35mm lens, shows the city in a topographical way. Such an approach is useful if you want to establish bearings and identify major landmarks.

*A street-level glimpse* of the Empire State Building (below) provides a very different sense of the city's skyscrapers. To obtain the pronounced blue cast in this picture taken at dusk, the photographer used film balanced for tungsten light.

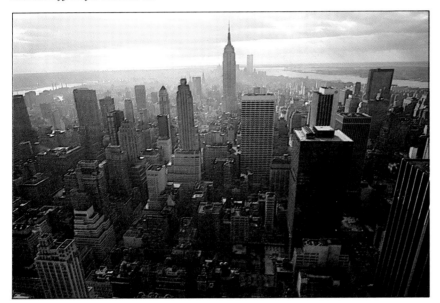

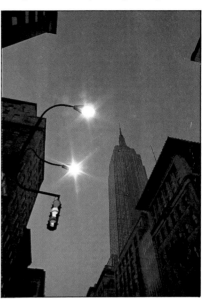

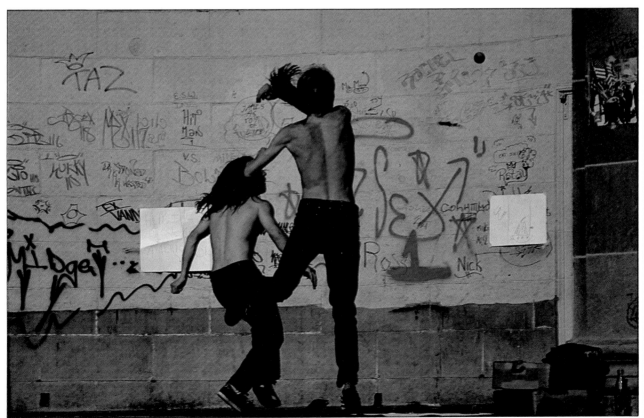

*Towers of light* dominate the view down Park Avenue (left). The photographer used a 200mm telephoto lens to bring the buildings forward and took the picture at dusk to combine some daylight with the brilliant street lighting.

*Two youths* playing handball against a graffiti-covered wall in a back street attracted this photographer's eye. He chose a fast shutter speed to freeze the figures' balletic movements, creating a powerful image of New York street life.

# Choosing the best viewpoint

Changing the viewpoint is a photographer's most important means of controlling the way the picture will look. Sometimes moving the camera only slightly can transform the whole composition. Indeed, one of the easiest ways to improve your pictures is to make a habit of moving around the subject to find the best camera position whenever you spot something you wish to photograph.

Seen from a level camera position, most scenes consist of a foreground, a middle distance and a background. The relative positions of objects on these planes can be altered dramatically by shifting viewpoint. Imagine a scene with a field in the foreground, a house in the middle distance, and a tree behind it in the background. Simply by moving your camera to the right, you will place the house to the left of the tree. A lower viewpoint might bring flowers in the field into the close foreground; a higher view would reduce the amount of sky in the

frame. By moving back, you could make the house appear smaller and perhaps bring extra foreground elements, such as an overhanging branch of a tree, into the photograph.

The photographs below illustrate how very different the same scene can look from various camera angles. Only by exploring all of the possible viewpoints before taking a picture can you hope to arrive at the best one. Of course, any subject may present you with a number of good viewpoints, all of which will produce equally satisfactory images. Then, your choice must depend on the aspects of the scene you find most interesting. An excellent way to learn both the techniques of composition, and the particular approaches to a subject that suit you, is to take a series of photographs from different positions and then compare the results. This might seem to involve a waste of film, but you will very likely gain insights that will save you film in the future.

**Four aspects of a single scene**
The Acropolis in Athens is one of the world's most photographed landmarks. These photographs demonstrate how moving the position of the camera can radically alter your impressions of the scene. In the first image, the buildings occupy the middle distance as overall shapes against the hills and sky. For the view at far right, the photographer moved in to silhouette the columns. The distant viewpoint below puts the classical monument into the context of a large modern city. Finally, the panoramic photograph, including tiny figures, provides a human scale.

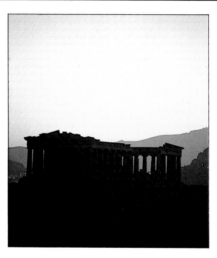

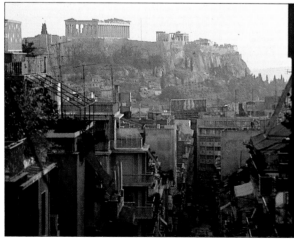

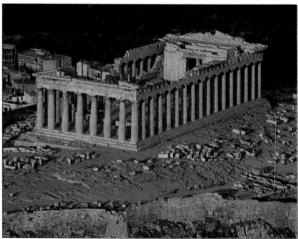

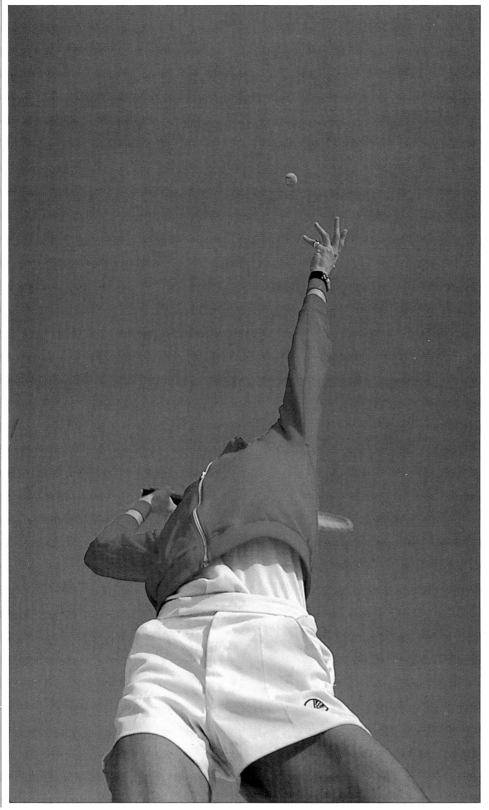

*A tennis player* throws up a ball to serve. The choice of viewpoint has fully exploited the explosive tension of the sport. When he had posed the subject, the photographer lay on the ground and aimed upward using a wide-angle lens. Thus, the lower half of the server's body appears distorted, emphasizing his leg muscles and long reach.

# The view through the lens

A change in viewpoint always leads to a change in the appearance of a picture, but there is another way to alter the composition without moving to a different position. This is to replace the camera's normal lens with one of a shorter or longer focal length – a wide-angle, zoom or telephoto lens.

If you change lenses on an SLR, the effects in the viewfinder are dramatic. With a telephoto lens, the view contracts in scope but enlarges in scale. With a wide-angle lens, the view broadens but objects within it appear to reduce in size.

However, the lens you use affects the image in other, more subtle ways. A wide-angle lens encourages you to move closer, to form a bigger image of nearby subjects. Since moving in closer does little to change the apparent size of distant objects, a wide-angle lens seems to expand a picture's sense of depth: close subjects seem even nearer, while distant ones appear farther away than they actually are.

This change in the relative sizes of near and far-off objects opens up a multitude of different choices in composing the image. For example, you can relate

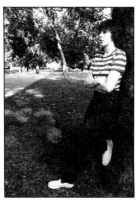  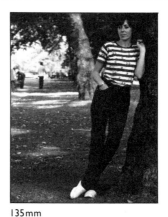 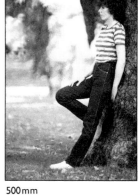

28mm     55mm     135mm     500mm

**Changing lens and camera position**
By backing away and changing lenses, the photographer who took these pictures changed the perspective but maintained the size of the figure. The result is four quite different views of the same subject.

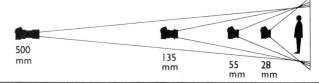

500 mm     135 mm     55 mm     28 mm

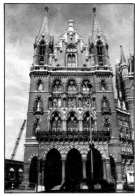 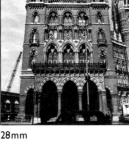 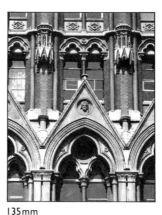 

28mm     55mm     135mm     500mm

**Changing the lens alone**
Using progressively longer lenses from the same position, the photographer was able to close in on a small detail of the building above. A change of lenses from a fixed viewpoint affects mainly the scope and scale of the image.

28mm
55mm
135mm
500mm

the foreground and background of the picture in a way that is impossible with a normal lens, as in the panorama at the foot of this page.

A telephoto lens has very different influences on the way you compose images. Its narrow angle of view compels you to choose extremely carefully the part of the subject you want to show. At the same time, the magnifying effect encourages you to stand farther away from a subject. When you are looking at a small selected area from a distant viewpoint, nothing looks the same as it does from nearby. The picture of guardsmen immediately below shows how the telephoto lens seems to compress perspective and stack objects on top of one another. In this way, the lens supplies a valuable way of translating three-dimensional subjects into the two-dimensional language of photography. You can use it to reduce the sensation of depth and compose pictures in which familiar objects become bold shapes and strident patterns, or to make arresting pictures from small subject details that would normally pass unnoticed in a broader view.

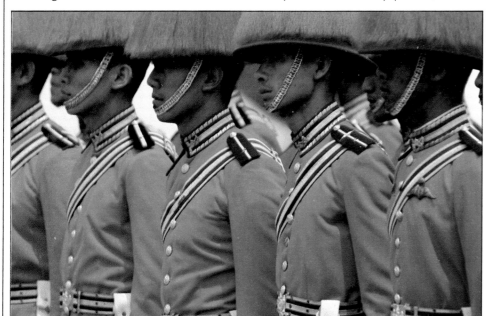

*A telephoto view of Thai guardsmen links their blue uniforms in a rhythmic pattern. From a viewpoint several hundred yards away, the photographer used a 200mm lens to eliminate the surrounding scene and to flatten the figures into a series of repeated motifs.*

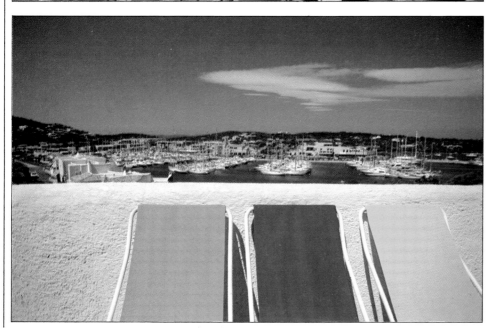

*A wide-angle view of a marina in Sardinia brings into the frame three sunlit deck chairs, echoing three ranks of the yachts behind. By using a 24mm lens, the photographer was able to let the blocks of bright color dominate the picture while cleverly linking them with the background.*

# Deciding the format

Usually one of the major decisions a photographer must make is whether to hold the camera horizontally or vertically. You do not face this choice with cameras that provide a square image. But with a normal 35mm camera, the proportions of the frame are strongly rectangular, and the positioning of this frame is often crucial in terms of both composition and content.

Because holding a camera horizontally is easier than holding it vertically, novices frequently take pictures this way without really considering the alternative. Of course, some subjects naturally suggest a vertical picture – for example, full-length figures, towers or tall buildings. However, even with these subjects there are situations in which you can compose the picture as either a horizontal or an upright image, as demonstrated by the two pictures here of a skyscraper.

Horizontal pictures usually create a more static, peaceful effect than do vertical images, which psychologically suggest vigor – the overcoming of gravity. Sometimes the best images are those that run counter to our expectations. Photographers refer to landscape format to mean a horizontal picture, and portrait format to denote an upright one. Yet a vertically composed landscape may bring interesting foreground or background details into the frame; and a horizontal portrait may be highly effective, as in the example below, in which the off-center placing makes the picture less rigid.

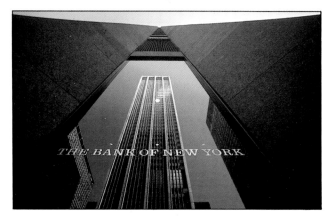

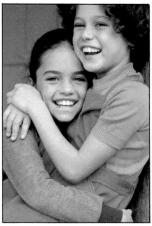

*A New York skyscraper,* reflected in the mirrored glass of a neighboring building, is intriguingly geometric in the horizontal format above, but gains thrust and impact when viewed vertically in the picture opposite.

*The double portrait* at left works naturally as an upright composition, the format helping to reinforce the lively upward movement suggested by the pose of the two girls.

*A deep-blue door* made a perfect background for the man in a blue sweater, and the photographer's first thought was to position him on the axis of the cross-bars in an upright portrait format. However, the effect was too static. By moving slightly to the right and holding the camera horizontally, he achieved a more successful asymmetrical composition.

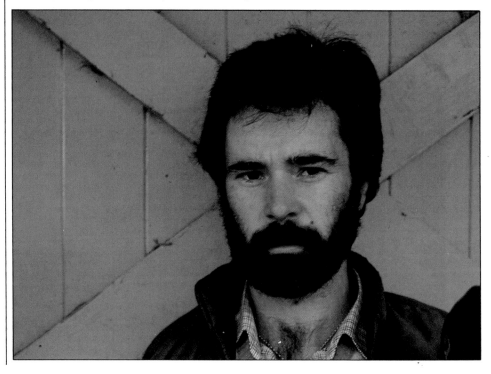

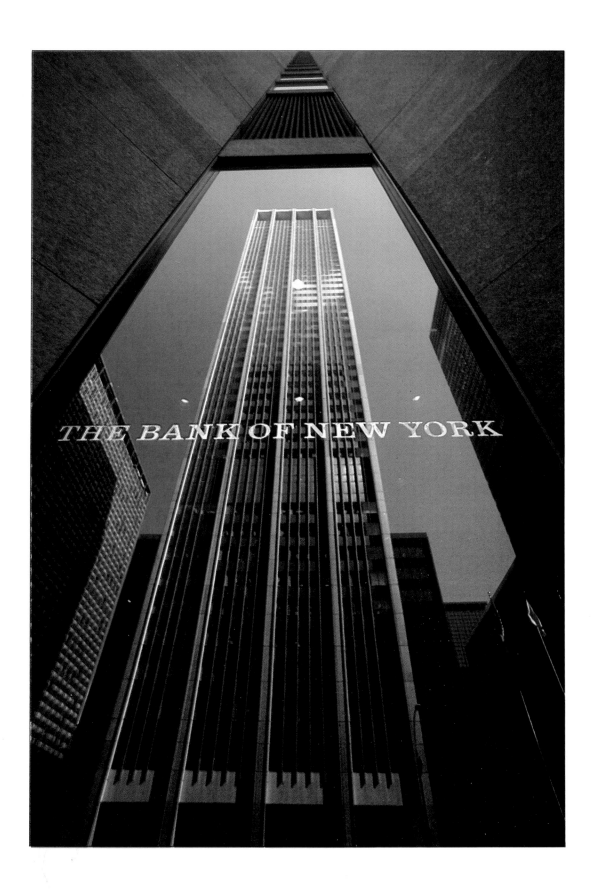

# The main point of interest

Whatever the subject, a picture is likely to have greatest impact if there is a main point of interest in the composition. Thus, before you decide how to approach a subject, try to identify the essential focus of attention.

Sometimes the center of interest is easy to spot. For example, the face usually dominates in a portrait, whereas in a landscape a particular tree, hill or stretch of water may provide the key element. When there is no obvious main point, you may have to look harder – or even create one.

Once you have a clear idea of what the main element in the picture should be, start thinking about how you can give prominence to this feature and ensure that other details in the scene do not compete for attention. Three very effective methods – used singly or in combination – will help to achieve this emphasis. First, you can frame the subject in such a way that distracting details are eliminated. In the picture at left below, the photographer excluded the horizon line, which would have marred the effect of the net outlined against the water. Second, you can make use of color or tonal contrasts between the subject and surrounding areas, as in the pictures of the beach sign and the bowler. Third, you can limit the depth of field by selecting a wide aperture and closing in on the main point, so that the subject appears in sharp relief. Both the bowler and the rose at bottom right on the opposite page were picked out in this way.

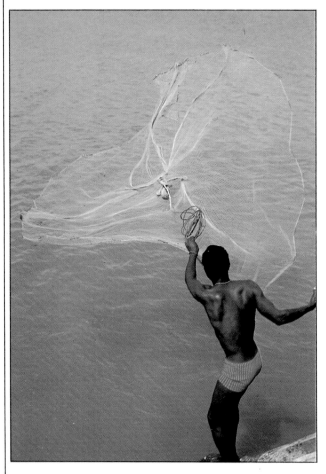

**The strong shapes** of both the net and the fisherman required careful framing to limit the picture to these vital elements. The photographer chose a vertical format and aimed the camera downward to eliminate the horizon and obtain a plain background.

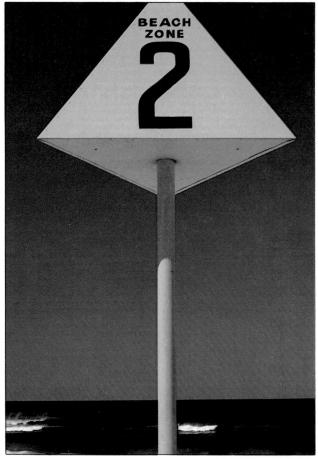

**The signpost,** one small detail in a cluttered beach scene, would lack any impact if photographed from a distance. The photographer spotted the graphic shape and exciting color contrast, and moved in close to isolate the subject from unimportant foreground elements.

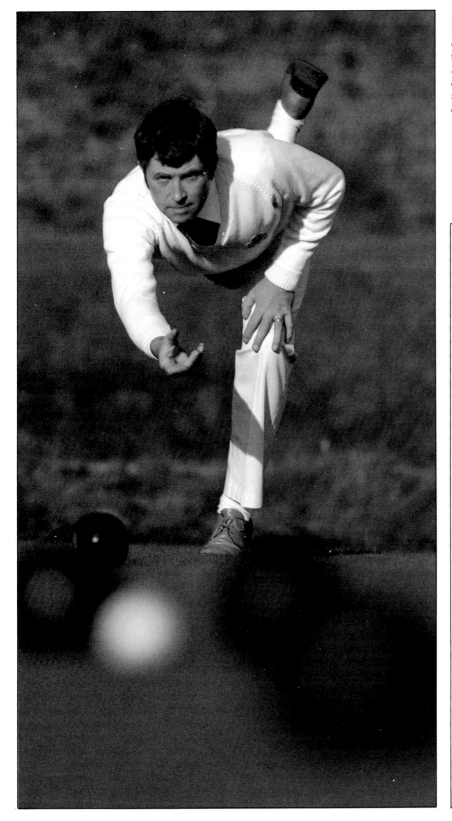

*At ground level* with a 200 mm lens, the photographer was able to combine dramatically this English lawn bowler's white target and his curious pose as he sent down another bowl from 30 yards away. The telephoto lens helped to isolate the subject with its narrow angle of view and a shallow depth of field.

1

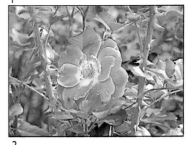

2

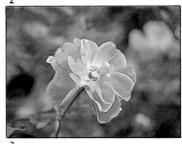

3

### Concentrating on the subject

A general view of a dog-rose bush (1) lacks a definite focus of interest.
By closing in and framing one main bloom against green leaves (2), the photographer improved the picture.
Opening the aperture wider (3) isolated a single in-focus flower.

# Supporting the main point

Photographs of a single well-placed subject have a bold, direct quality. But this approach also imposes limits on composition. You can extend your scope, broaden the range of interest in a picture, and say more about a subject by including subsidiary elements to back up the main point. Each of the three large pictures on these pages has a strong central subject that could stand alone. But in each, the subject is enhanced by the presence of supporting points of interest.

Organization is important when you are combining several different elements in a picture. Try to balance the various elements within the frame, and make sure there is a visual continuity between them. The aim should be to lead viewers smoothly and immediately to the center of interest, and then persuade them to take in other details. When objects in a scene are of similar size or shape, you can use perspective to accentuate the main feature. For example, you might choose a camera position that places the less important elements slightly to one side and behind the main one. A good way to subdue a secondary element in the foreground is to crop out part of the shape. The picture of the girl on the beach at bottom right shows this.

Elements with a similar pictorial weight will tend to compete for attention if they are placed side by side. Often, however, a contrast in scale or appearance allows you to juxtapose elements on the same plane without conflict, as shown in the image at right. Whatever the subject, try a number of different viewpoints if possible before choosing your approach. The sequence of photographs at far right shows how radically a change in camera position can alter the relationships of elements in an image.

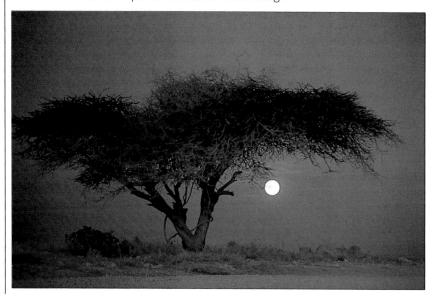

**Humdrum objects,** *carefully linked, become an absorbing study in form and color. The pipe and faucet, well defined by the dark-red background and placed in the strongest position within the frame, provide a center of interest. The solid area of even color produced by the stone base gives weight to the left-hand side of the image and restores balance.*

**The matted shape** *and twisted trunk of a tree (left) make impressive subjects for a photograph. By experimenting with various viewpoints, the photographer was able to find a position in which the full moon was not obscured but appeared to be suspended from the branches. The moon both illuminates the colors of the parched landscape and provides a subsidiary element to support the main subject.*

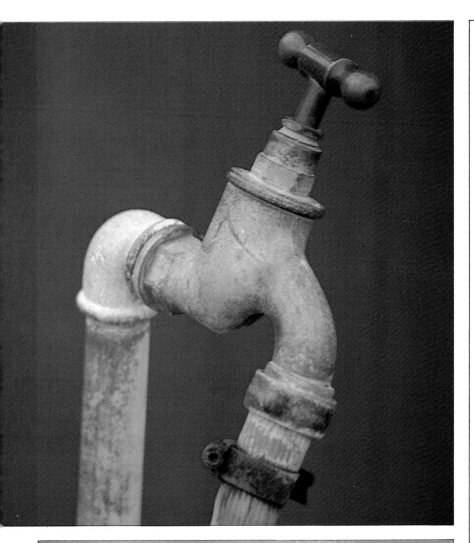

## Organizing the picture

Shifting the viewpoint is often the best way to change the relationship of objects within a scene so as to support the main subject. A random scene of the boating lake below was full of confusing detail (1). The photographer then chose a life ring as the main subject, with a single deck chair as the second element, and changed his viewpoint to isolate them against an empty stretch of water (2). A closer view kept the two elements in a balanced relationship while stressing the colors and shapes (3).

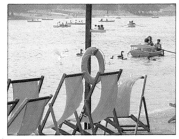

I

2

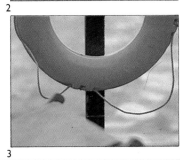

3

*A shapely, tanned figure outlined against pounding surf (left) would have made an arresting subject alone. But the extra foreground elements of a chair and towel, carefully cropped, enhance the balance without diverting attention away from the girl. They also add depth to an image otherwise flattened by the photographer's use of a telephoto lens.*

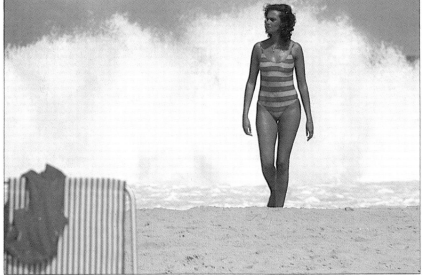

29

# Harmony and balance

The basic principles of composition that underlie most successful photographs are not rules to be followed slavishly. But understanding them will help you to produce balanced and pleasing images.

A key principle is that the main subject should occupy a strong position in the frame. One method of locating such a position is to divide the scene in the viewfinder into thirds, horizontally and vertically, as shown in the diagram at bottom right on the opposite page. The four intersecting points are all areas of strength within the frame, and placing the main subject a third of the way across the frame can work well providing there are other elements to balance the image. In pictures with a single point of interest, the "golden section" is a more useful principle. This classical rule governing aesthetic proportions places the subject slightly closer to the center, thus avoiding imbalance if there is a large area of empty frame. The diagrams at the top of the opposite page illustrate the difference between these two approaches. Both principles have the practical effect of placing the subject off-center, so that an image is not too symmetrical and static. However, if a subject depends on symmetry for effect, as in the image below, the central position may be the best.

Another important way to create effective pictures is to use lines or tones to lead the viewer's eye toward the main subject. Converging lines will draw the eye, as will a gradation of tones, with a dark-toned foreground leading back to progressively lighter tones around the main point of interest. The landscape photograph below at right shows both of these techniques.

Color relationships can be used to great effect in balancing an image. For example, a small area of bright color, placed on one division of thirds, could keep the eye from being drawn too heavily toward a main subject positioned on the other third. Conversely, strong colors or highlights near an edge of the frame can spoil a composition by diverting attention away from the main point.

*The stylized symmetry of the facade at right would have been less striking had the photographer not carefully centered the subject. The picture at right shows how a human figure, when placed on two of the strong lines, adds interest and prevents the image from being too static.*

## Positions in the frame

The four diagrams show how the positioning of the subject will affect the balance of the composition.
**1**–This diagram shows the eye's view of the scene.
**2**–With the main point of the picture in the center, the image is dull.
**3**–A more interesting effect emerges with the scene divided into thirds by the figure and the house on the intersections.
**4**–With the main subject standing alone, the best position is on the golden section, dividing the frame into proportions of eight to five.

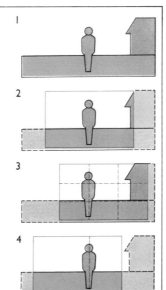

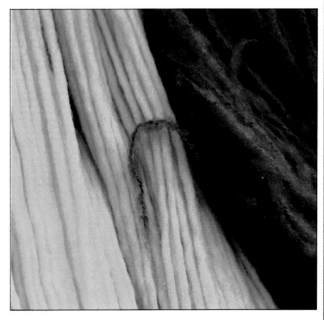

*Skeins of wool* in perfect visual balance make up a satisfying abstract image. Using a close-up lens, the photographer framed the picture to give more space to the lighter yellow wool, while a loose strand from the weightier blue pulls the elements together.

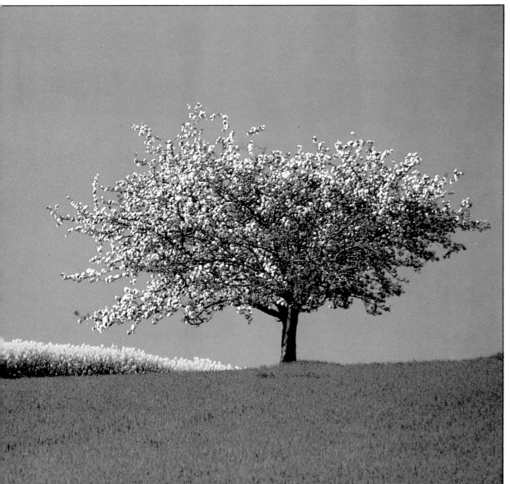

*A tree* laden with blossoms commands the horizon. As the diagram below demonstrates, the tree and the yellow field, a supporting subject, both lie on a dividing line of thirds. The slope of the field leads the eye down toward the main point, while the dark foreground draws the viewer into the frame.

# Discord and drama

Once you understand the principles governing harmony in a picture, you have a valuable second option – that of bending or breaking the rules. This may seem perverse, but discord and imbalance applied in a controlled, deliberate way can improve good images and keep others from being dull.

Placing the main subject near the edge of the frame rather than on an intersection of thirds is one approach. By drawing attention to a corner of the picture and using subsidiary elements to pull the viewer back toward the center, you create visual activity in a potentially static scene. The amusing picture of the dog, below, is an example. In a more conventional shot, the dog's contrived ensemble might have made a flat and obvious subject. This composition also illustrates another technique for adding life to an image: cropping. By showing only the women's legs, the photographer emphasized one outstretched foot as a linking device.

Whereas lines that are essentially parallel to the sides of the viewfinder frame suggest serenity and harmony, the presence of a strong diagonal line creates vigor and a sense of motion. The inclusion of a conflicting diagonal exaggerates the effect, as in the sailing picture at right. Colors, too, can be juxtaposed to conflict with one another. The composition on the opposite page is an extreme example of the way divergent lines and strong colors can create drama and excitement in an image. Before using any of these techniques, think about whether the subject really suits such an approach. Discordant elements can ruin a picture if introduced unnecessarily.

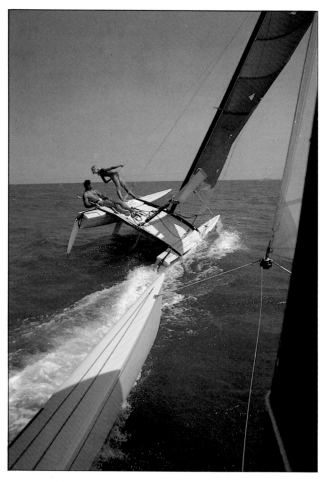

*Strong diagonals* of two speeding catamarans give a dynamic sense of movement to the image above. The figures, placed on an intersection of thirds but leaning outward, create visual tension by pulling the eye in a direction away from the vessel's path.

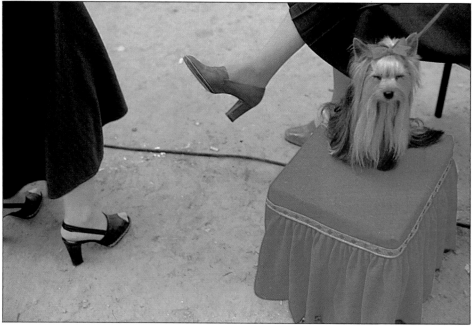

*Unorthodox framing* and cropping give the picture at left a lively and satirical quality. The position of the pampered pet gives uneven weight to the bottom right-hand corner. But the angle of the seated woman's foot carries the eye back into the picture, and then to the graphic figure at left.

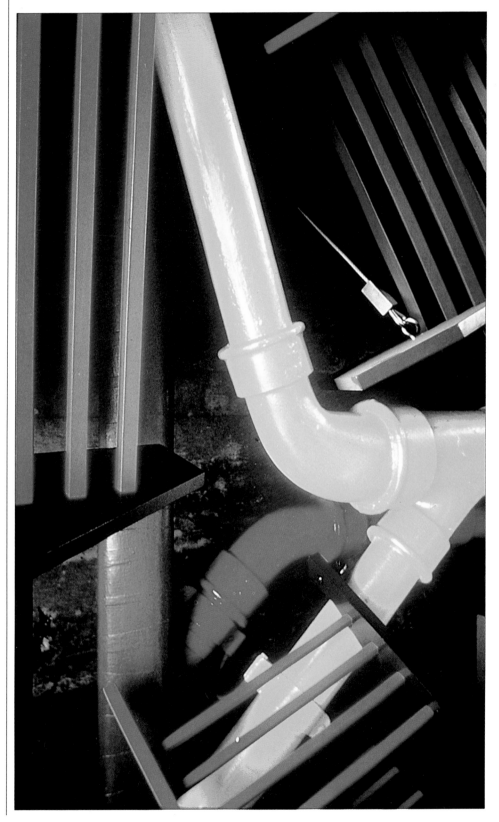

**Clashing primary colors** and confusing shapes give this abstract image a turbulent, aggressive quality. The discordant colors and lines all compete for attention, so that the eye has difficulty in finding a resting place. The result is a successful, provocative composition.

# The critical moment

In many pictures the location of each element of the subject within the frame is what determines the success or failure of the composition. But when the elements of a scene are changing, the most effective way in which to frame the image may depend to a large extent on the critical moment at which you decide to release the shutter.

This is easiest to appreciate with an action-packed subject such as a tennis match or other sporting event. However, precise timing may be crucial to success even with subjects such as landscapes, in which the changes taking place may be more subtle. Often you will have to observe the scene for several minutes and wait until all the picture elements are just right. For example, to capture the marvelous greens of the seascape at top right, the photographer watched the breaking of the surf and the movement of clouds until the moment at which the contrast of light and dark greens was most intense. Sometimes, too, a scene may seem to lack only one vital ingredient to complete the picture, and you will need to combine patience with constant alertness until the missing element appears, as in the photograph at left below.

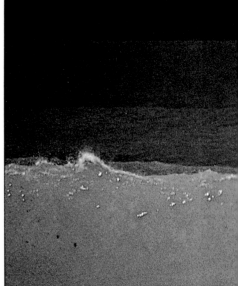

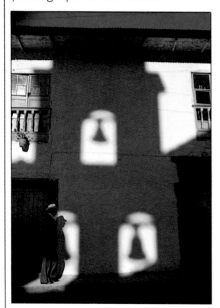
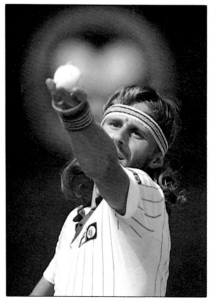

*A strolling figure* steps into a pattern of shadows, and the composition suddenly crystallizes. The shadowy bell tower drew the photographer's attention initially, but the picture seemed to need just a touch of movement. Precise timing caught the man at the moment when light picked up his hat and silhouetted him on the wall.

*Poised to serve,* tennis pro Bjorn Borg concentrates intently. The photographer used a telephoto lens from the far end of the court and chose this moment of stillness, rather than the frenetic action of a rally, to better express Borg's steely calm. Floodlights flaring into the lens created a soft halo effect.

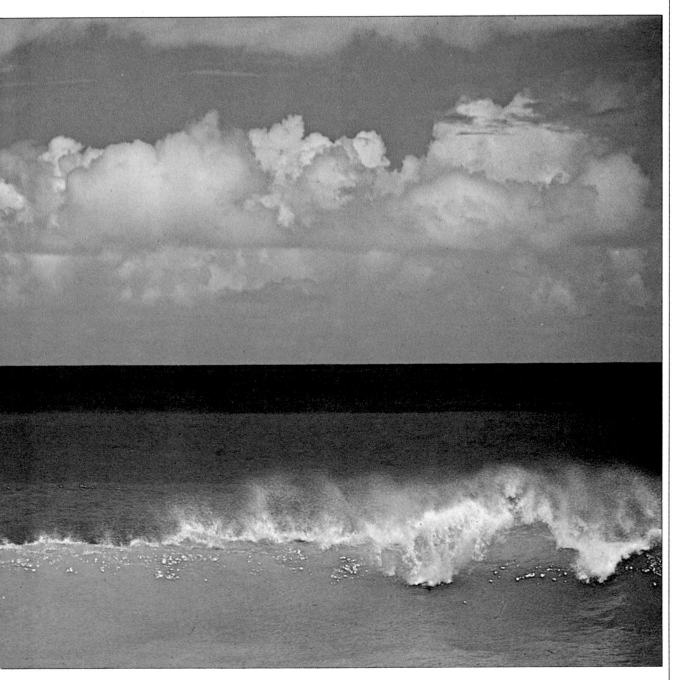

*A breaking wave sparkles against the heavy green of a sea darkened by cloud. Ernst Haas, one of the great masters of color photography, caught this split second of beauty by releasing the shutter at the moment when a shaft of sunlight lit the wave's toppling crest.*

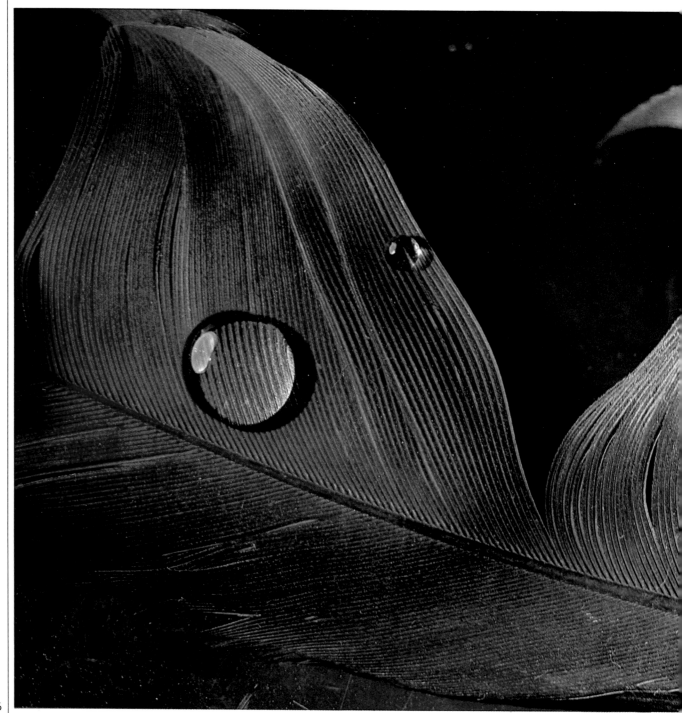

# THE GRAPHIC IMAGE

Usually in framing a scene carefully in the viewfinder, adjusting the camera angle to improve the view, or making sure the light is just right, photographers are enhancing subjects they want to record. However, some other pictorial qualities can themselves become main subjects. For example, the photographer who took the picture of a feather at left responded to the shapes created by the outline, to the sheen of light on the surface, and to the contrasting textures of the feather and drops of water. If the feather itself had been the main subject, he would have included more of it and adjusted the lighting to reveal the colors in a more naturalistic way.

This section shows how to recognize purely pictorial qualities such as shape and form, pattern and texture. In addition, it deals with the important element of tone in composition, and with aspects of contrast and exposure that influence the mood and atmosphere of photographs. A heightened awareness of all these qualities can strengthen any kind of picture. And by consciously looking for them in everyday scenes you can open up a whole new source of subject matter.

*This startling image of a feather combines the compositional elements of shape, texture and tone. The photographer used a special close-focusing 55mm lens and positioned the feather a few inches from a dark background. A lamp on the left and a white card reflector on the right provided the light.*

# The bold shape

The silhouette of a figure or a familiar object against the sky gives us only a little information. But usually the few clues that such a flat image provides are enough for us to be able to recognize a friend or to identify the object at which we are looking. In photography, this stark, two-dimensional quality – known as shape or outline – has a swift, dramatic impact, and can act as a kind of visual shorthand.

To make an effective picture, you need not reduce a shape to a complete silhouette – though this may suit some subjects. What is essential is to create a strong contrast between subject and background. You can achieve this in several ways, depending on the nature of the subject. For example, a dark-toned subject positioned against a light-colored back-ground will provide a strong shape by means of tonal contrast. You can use a background of contrasting texture or color in the same way.

Usually, however, it is the angle of the camera in relation to the light source that has the most profound influence on shape, as shown at top right. In addition, a subject is most easily recognizable from a particular angle. Thus, you need to consider the most effective position from which to take the picture. Moving around the subject also helps you to find the most effective juxtaposition of subject and background. You may also discover that the shape would be clearer under a different light, and you should come back at another time – perhaps when the sun is lower in the sky.

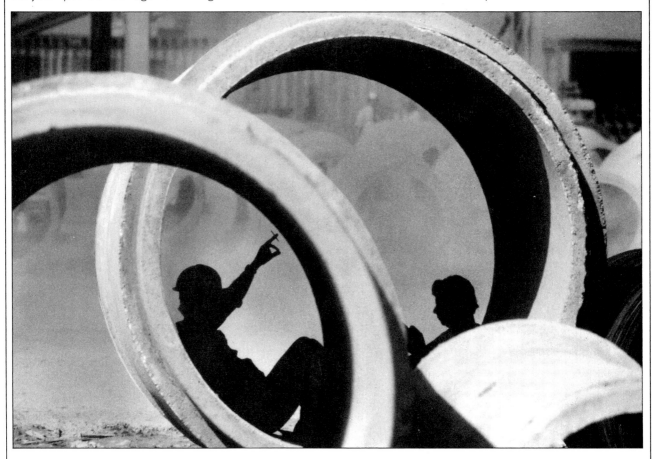

*A concrete pipe shades construction workers from the sun. The photographer noticed them eating their lunch and moved around to silhouette their dark shapes – and the enclosing ring of the pipe – against the dusty building site.*

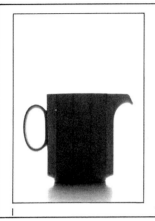
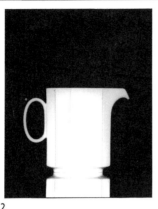
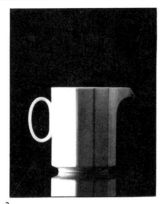

**Light and shape**
Outlined against a lighted backdrop (1), or strongly lit from the front against a black backdrop (2), the pitcher stands out clearly as a bold, graphic shape. But with sidelighting (3), shadows and highlights make the shape much less emphatic. Outlines are clearest with the camera angled directly at or away from a light source.

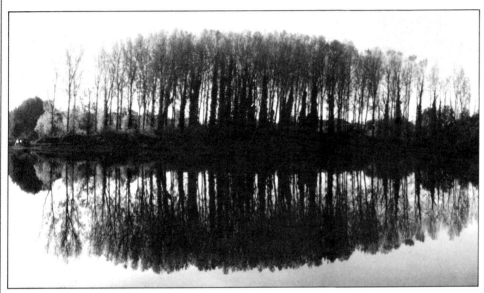

*Lakeside trees reflected on a still morning form a delicate double shape against a pale sky. To emphasize the symmetry, the photographer composed the picture with the waterline cutting the frame exactly in two.*

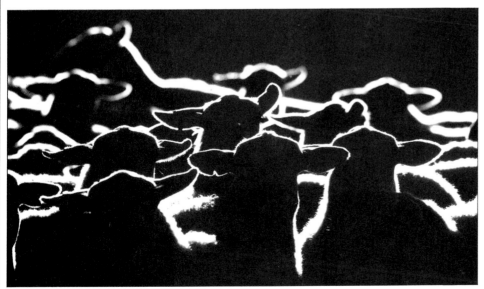

*A flock of sheep stare blankly at the camera, their woolly outlines picked up by the setting sun. To achieve this effect, the photographer moved around until the light was directly behind the flock. Then he set the camera controls to underexpose by two stops to exaggerate the rimlighting.*

# Form and the image

Although shapes alone can make striking images, the information they convey is too limited to show whether an object in a picture has weight, solidity and depth. For this, a viewer needs some indication of form – some variation of light and shade within the outline. Such tonal variations are what give objects the illusion of depth in a photograph.

Light alone governs form, providing the visual clues that convey an object's bumps, hollows, curves or receding surfaces. For example, an orange lit strongly from behind will appear only as a dark, flat disc. But if you soften the light, the shadows on the outer rim will begin to lighten and indicate the orange's curving sides. And if you move the light around so that it falls obliquely on the orange, the

gradation of tone from highlights to shadow will reveal the full roundness.

The quality and direction of light best suited to revealing form depends to some extent on the subject. Oblique morning sunlight raking across modern buildings may bring out their angular forms dramatically. But when you want to show more softly rounded curves, as in the picture of weed-covered boulders on the opposite page, the soft light of a cloudy day will give a better impression of form. Bright sun would have thrown a confusing pattern of light and shade over the rocks. For the same reason, moderately diffused light is best for revealing the subtle forms of the face when you want to achieve a balanced effect in portraiture.

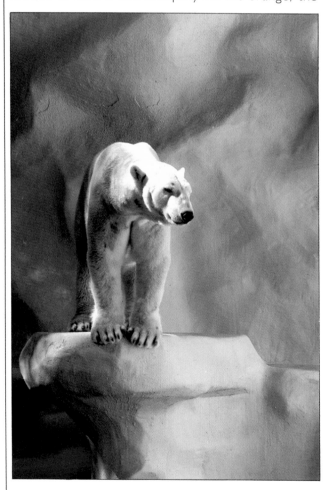

*Dappled sunlight models the soft, rounded forms of a polar bear and the ledge it stands on. Flatter light would not have separated bear and background so well.*

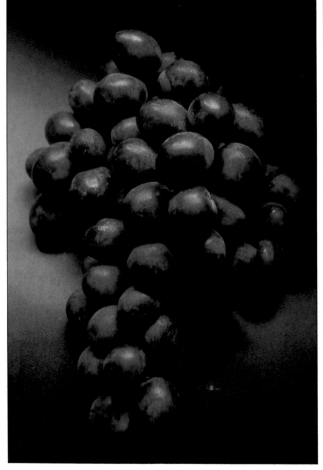

*Lustrous grapes, lit obliquely by a low, angled spotlight, have an almost tactile plumpness – an effect created by the play of highlights and shadows.*

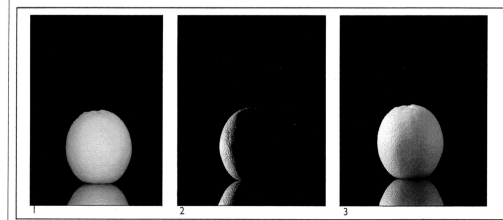

## Light and form

Frontal lighting (1) shows relatively little of the orange's form. But harsh sidelighting (2) also may disguise form by picking out only one edge. Softer light from one side (3), and the use of a reflector to direct some light back to the other side, gives a truer picture of the rounded form and the texture of the orange.

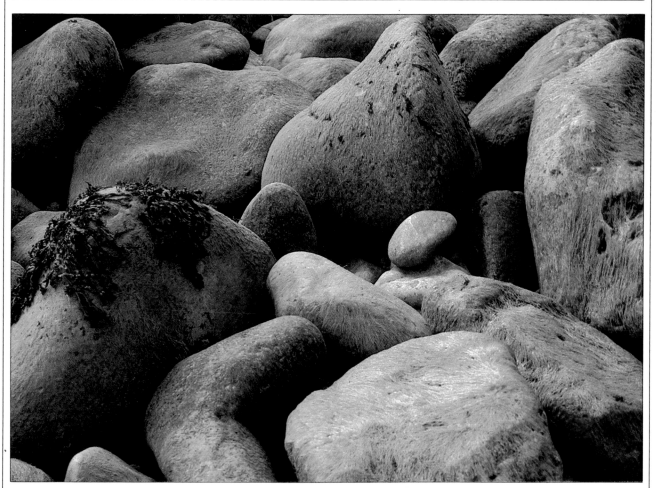

*Sea-washed boulders in this simple study take on a sculptural power because variations of tone and hue, revealed by diffused light, convey their rounded weight.*

# Visual rhythms

Just as you can use strong lines to direct a viewer's eye toward a point of interest, you can maintain this movement within the frame and set up a visual flow or rhythmic beat that gives a sense of vitality to a photograph. How you achieve this will depend on the nature of your subject.

Many subjects have an obvious visual flow – the swirling fern fronds below, and the waterfall-like tiers of the modern building on the opposite page are good examples. But often you can make a rhythmic picture from many apparently dissimilar elements. In the picture at the bottom of this page, each rock has a unique shape, but the photographer has blurred the sea so that it winds through the picture like a mist, linking one rock to the next and suggesting a common structure.

Often the rhythms of seascapes or landscapes are not apparent to the eye because of the distance between repetitive elements. But a photograph, which brings everything together on the flat plane of the picture surface, can eliminate the sense of depth and provide connections between near and far elements. To exploit this, try to look at a subject as a camera does, ignoring the subject's real three-dimensional nature. By framing the picture so that indications of depth are reduced, you may be able to find rhythmic patterns that will give the image strength and visual interest.

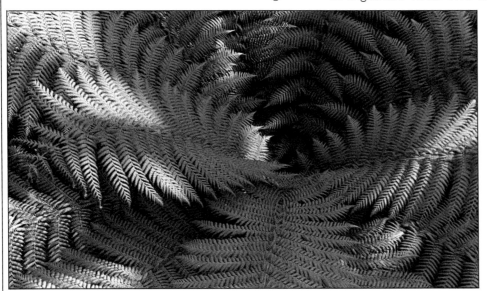

*The fronds of a fern* make a rhythmic pattern that leads the eye round and round the photograph. By closing in to eliminate foliage around the plant, the photographer has emphasized the convergence of the delicate fronds and the similarity of their leaves.

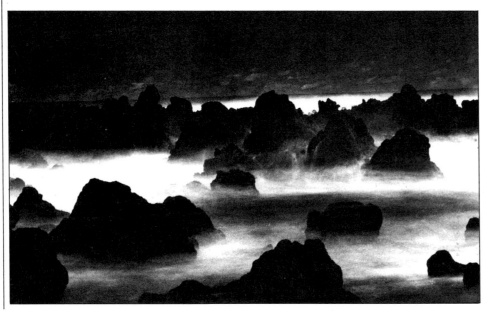

*Jagged rocks* set up an uneven tempo accentuated by the simplified background that the sea provides. To blend together the broken shapes of the waves into a soft, misty veil enveloping the rocks, the photographer put the camera on a tripod and kept the shutter open for several seconds.

*Modern buildings* have their own rhythms. At right, the photographer has framed one in São Paulo through a 200mm telephoto lens in such a way that the lines seem to cascade downward past a solitary figure at the edge of the picture.

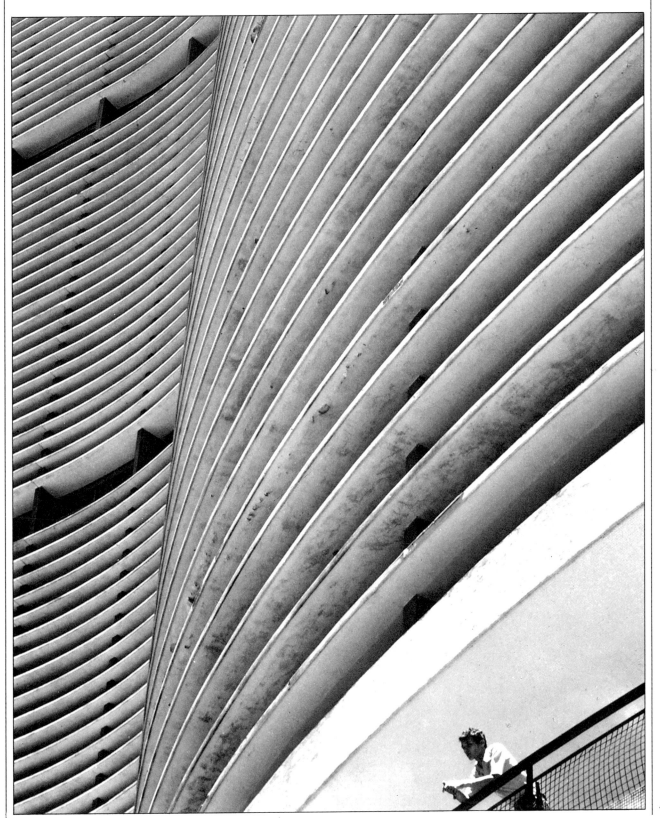

# Pattern/1

Patterns depend on the repetition of similar shapes, forms, lines or colors. Because such repetitions attract our instinctive attention, they can be a powerful ingredient in photography. And you can easily compose pictures to bring out patterns by identifying repeated elements in a scene and then isolating the part of the view that contains them. In the three pictures here, close framing of much larger subjects has emphasized the patterns they contained and excluded any distracting elements.

Landscapes make excellent subjects for experiments in photographing patterns. The furrows of a plowed field following the contours of the land, or the regularly planted rows of trees, as in the huge olive grove on the opposite page, give visual structure to scenes that might otherwise appear featureless. You can accentuate such patterns when the light from a low sun at right angles to the camera casts shadows that emphasize the repeated shapes of trees or the snaking lines of ridges and hollows in the land. The higher sun of midday tends to fill in the shadows and make a landscape seem flat. For example, in this kind of light the olive trees would have merged more with the parched ground, and their pattern would have been less striking.

The man-made environment is also full of patterns. Standardization of manufactured objects in bold colors and clean shapes creates infinite possibilities for anyone with an alert eye. The umbrellas below were scattered randomly to dry, but the photographer chose a viewpoint that creates order through repetition of shapes, lines and colors.

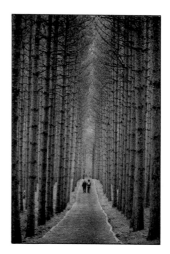

*A lone couple* walking in the forest provide a focus for the pattern created by the rows of tall trees lining their way. The photographer centered the path perfectly and kept the camera level so the trees would appear vertical in the picture.

*Gaudy umbrellas* lie in a jumble that the photographer organized by framing. A small aperture ensured that the entire depth of the subject would be in focus.

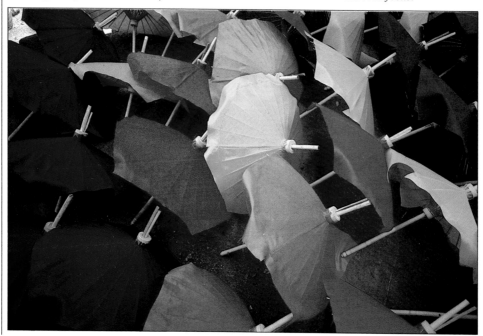

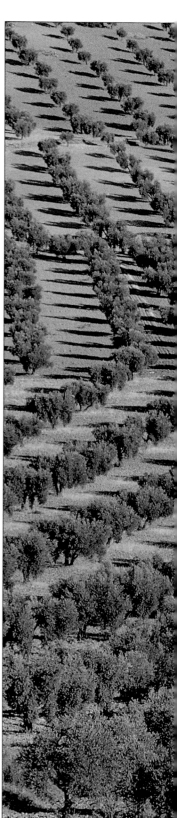

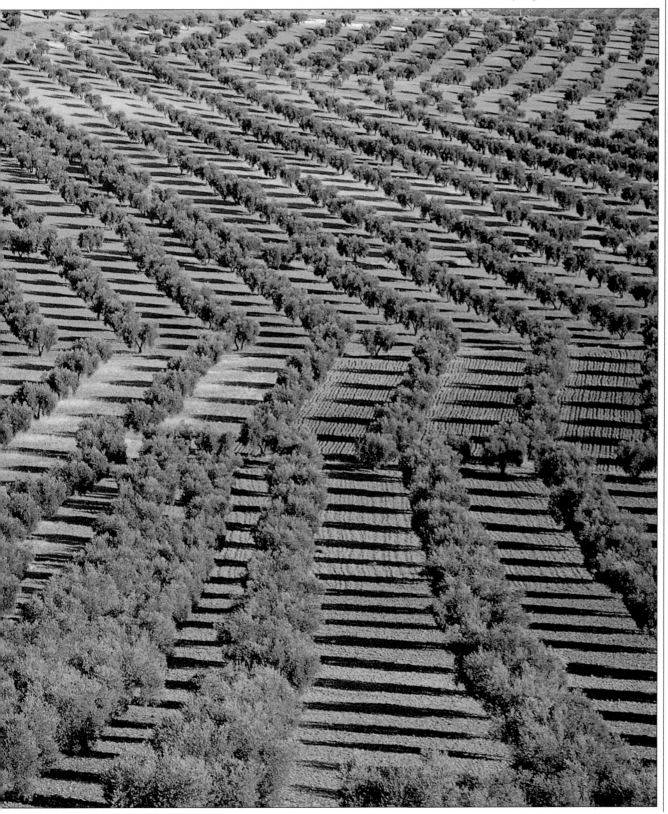

*Long rows of olive trees* stretch across a Spanish plain, framed so that their immense pattern is unrelieved by the distraction of either sky or foreground.

# Pattern/2

Some of the most striking images come from geometric patterns found in architecture, industry, and sometimes in nature. Sharp angles and strong lines tend to produce stark contrasts of light and shade that allow you to create almost abstract images, which are interesting precisely because the subject is difficult to interpret.

Geometric patterns can look particularly effective in black-and-white. By excluding color from the picture, you reinforce the interplay of tones and repeated shapes. A slow film, such as Kodak Panatomic-X (ISO 32), has very fine grain, giving sharp, clear edges to the patterns. You can add to the abstract effect if you have the negatives printed on a hard paper – grade 3 or 4 – to increase contrast. Because the intention is to bring out sharp tonal contrasts, strong sunlight is the best kind of lighting for abstract patterns, casting dark, rigid shadows. Close framing will help to remove the pattern from its context and emphasize the purely formal qualities of the picture so that you see it more as an abstract design than a representational image.

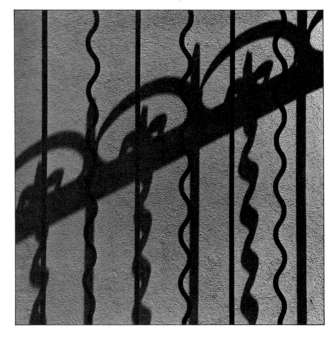

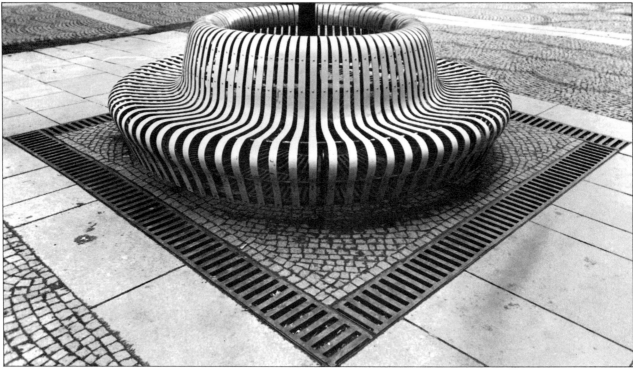

*The curved slats* of an iron bench contrast with the more rigid geometry of the pavement. The photographer used a wide-angle lens and pointed the camera down to exclude the background.

**An ornamental railing** *(left) casts sharp shadows on a textured wall. Close framing and hard light show the bars purely as flat shapes.*

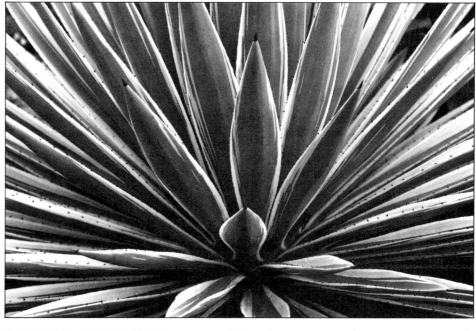

**A spray of spiky leaves** *filling the frame (right) seems to explode outward. By closing in and taking the picture in strong sunlight, the photographer stressed the plant's regular structure.*

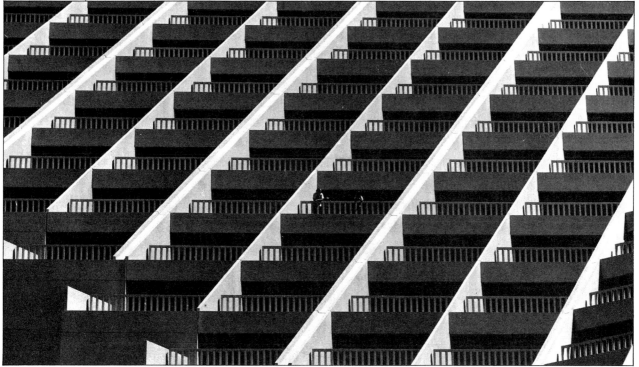

**Horizontal balconies** *and diagonal wall surfaces create a severe geometric pattern. The photographer moved round the building and used a 200mm telephoto lens for this bold and dramatically angled view.*

47

# The strength of line

Line is often the basis of composition. Look at a scene through half-closed eyes and you will notice that a few strong lines or contours give definition to everything else. At the same time, lines generate a sense of movement into or around a picture space, because we instinctively follow them with our eyes.

Analyzing a random selection of successful photographs will give you an idea of the many ways of exploiting linear effects to support or enhance subjects. Lines can balance an image, drawing the eye toward the main point of interest and linking other elements together, or they can cause discord. The flowing contours of a figure can suggest a supple roundness, as in the picture at the bottom of this page. And at the right time of day, deep shadows in a landscape can create the kind of strong graphic lines seen in the picture of sand dunes below. Although here the flat, solid tones exaggerate the two-dimensional quality of photography, lines can also be a powerful means of creating an illusion of depth. The converging lines of a street or of an avenue of trees receding into the distance are examples of classic linear perspective. The picture of power lines opposite illustrates a more unusual perspective effect: the lines do not meet in the distance, but sweep up sharply out of the frame.

Often the mood of a picture is affected by the sort of lines that dominate. Angles and jagged edges tend to convey a sense of aggression and restless energy, whereas the gentler rhythms of curves, especially those of the human body, can suggest a soft, romantic mood.

*Dense shadows* create a sinuous ribbon that divides these dunes into abstract shapes. The photographer obtained these strong lines and dramatic tonal contrasts by taking the picture when the sun was low in the sky.

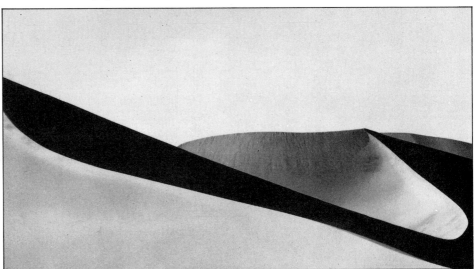

*The gentle contour* of a nude woman reclining on her side (right) suggests warmth and sensuousness. Broad, diffused light bounced from a large reflector creates a subtle tonal interplay that helps to soften the contour.

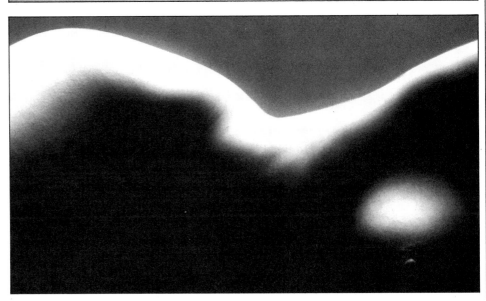

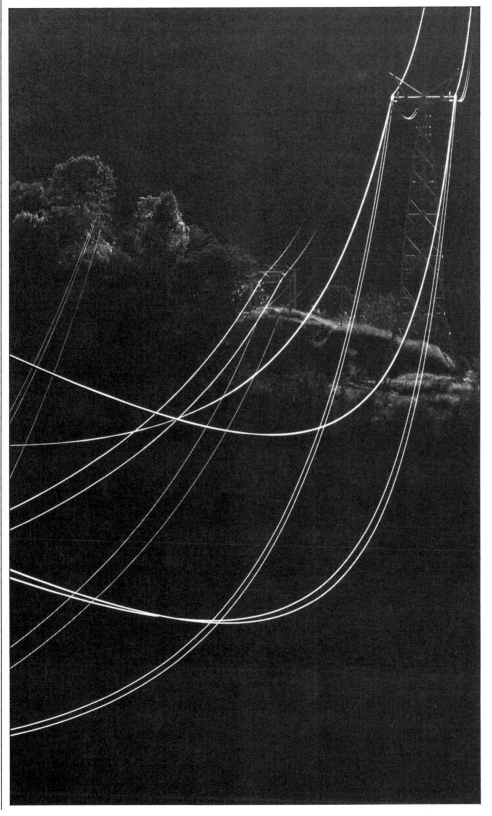

*Power cables* spanning a deep valley form a network of fine, intricate lines looping upward out of the frame. The effect of the bright sunlight highlighting the cables makes them stand out boldly against the dark background.

# Surface texture/1

Sometimes a photograph records the texture of objects in such astonishingly sharp detail that the surfaces look real enough to touch. The picture on the opposite page is a superb example: you can almost feel the differences between the coarse stiffness of the ropes, the softer cords of the loose-weave fishing net and the springy mass of finer netting. Pictures based wholly on such textural contrasts have an attraction of their own because they convey both visual and tactile sensations.

Texture, sometimes equated with uneven surfaces, can in fact range from the roughness of coarse-grained surfaces to a velvety sleekness, and the contrasts between such different surfaces can give great richness to a picture. For example, in the landscape below, the clouds echo the tufted grasses – but with a softness that differs interestingly from the sharp-bladed texture of the grass. If you want to concentrate on textural qualities, you may need to subdue other elements of the picture. Just as too much detail can lessen the impact of a bold shape, well-defined shapes and strong colors may detract from texture. For this reason, some of the best and most striking photographs of surface texture are simple black-and-white close-ups, which appeal because of their graphic simplicity.

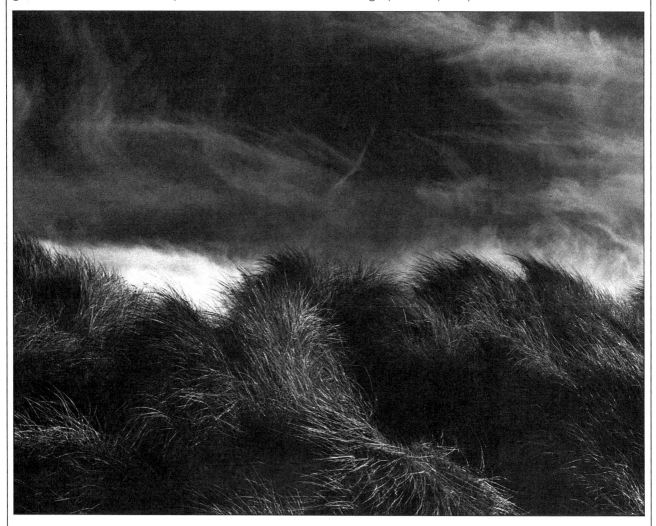

*The brushlike texture* of wind-blown grass forms a dramatic contrast to low, wispy clouds. The photographer took the picture with a red filter to darken the blue sky; against a lighter tone, the clouds' delicate texture would have been lost.

*A jumble of fishing nets* and ropes, framed tightly in close-up and precisely focused to record every knot and ply, yields an intricate variety of textures. The picture needed a very narrow aperture to achieve maximum clarity.

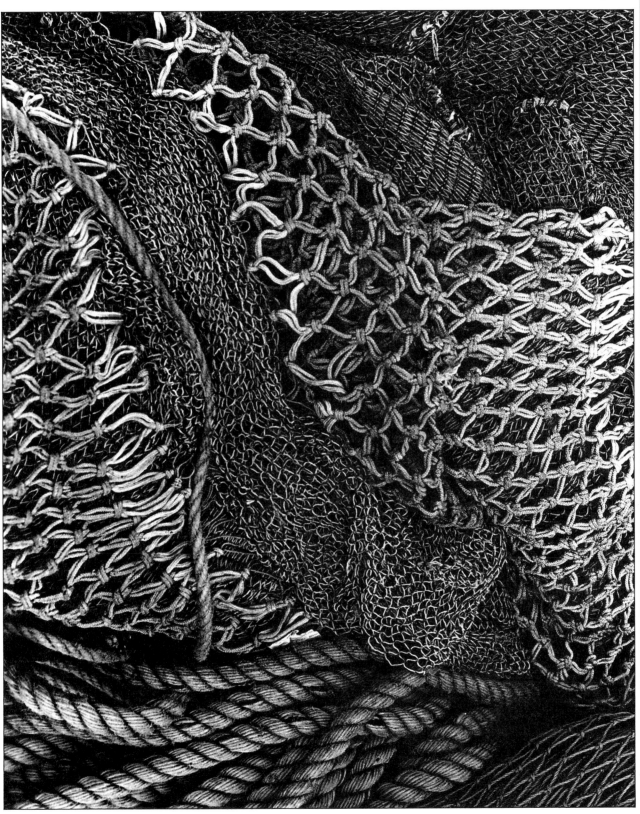

# Surface texture/2

With the right lighting, you can pick out rugged surfaces in sharp textural relief or reveal a fine texture in surfaces that seem almost completely smooth to the eye. The photographs on these pages show the importance of lighting in recording the different textural characteristics of a range of subjects.

Generally, to bring out texture the light should come from an oblique angle so as to rake the surface of the subject, highlighting each small relief and creating shadows within the indentations. The lower of the two pictures of sculpture at right shows how shadows bring out the relief. A subject with a very delicate texture, such as an eggshell, needs more acutely angled light than does a coarse-textured subject, such as tree bark.

The quality of light is also important. As a rule of thumb, finely textured surfaces need softer, more diffused lighting to bring out their qualities than do rough surfaces in pictures that seek more dramatic effects. The bright highlights and dense shadows cast by strong light will obscure finer details, although a hard light can suit glossy surfaces, such as the painted door at far right.

**Oblique light and low relief**
Lighting can accentuate or mask a subject's overall texture, as these pictures of an architectural relief sculpture demonstrate.
(1) The soft, diffused light of early morning shows the design as almost flat.
(2) Late in the day, the sun casts a strong, raking sidelight that picks out the relief and the texture of the old, weathered stone.

1

2

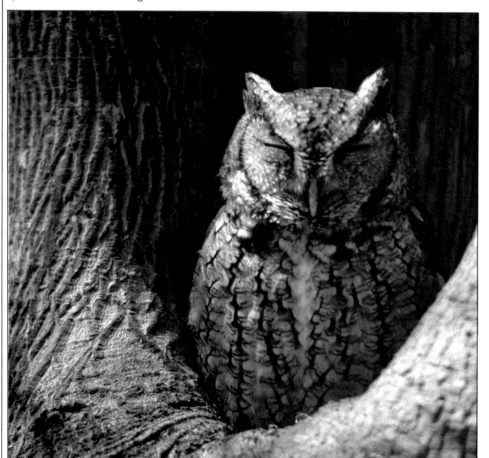

*A sleeping owl* perches in a tree hollow. Soft, low-angled sunlight picks up the pattern of feathers and creates an extraordinary but illusory resemblance between the harsh texture of the ridged bark and the downy softness of the owl.

*Rough and smooth,* shiny and mat surfaces make an attractive combination in the still-life on the opposite page. Bright, diffused sidelighting brings out the contrasting textures of the crusty loaves of bread, the wooden surfaces and the ceramic pot.

*A smooth surface can be just as interesting as a rough one. Here, strongly oblique light shining on a gloss-painted door shows up the slick, heavily coated texture.*

1

2

### Oblique light and high relief

The papery seed pods at left have rounded forms that present a higher relief to an oblique light than do the fine sculpted ridges opposite.
(1) Soft light shows a delicate tracery of veins in the seed pods, but the picture works mainly as a color pattern.
(2) Hard, oblique light shows some texture better, and the shadows bring out the forms of the pods.

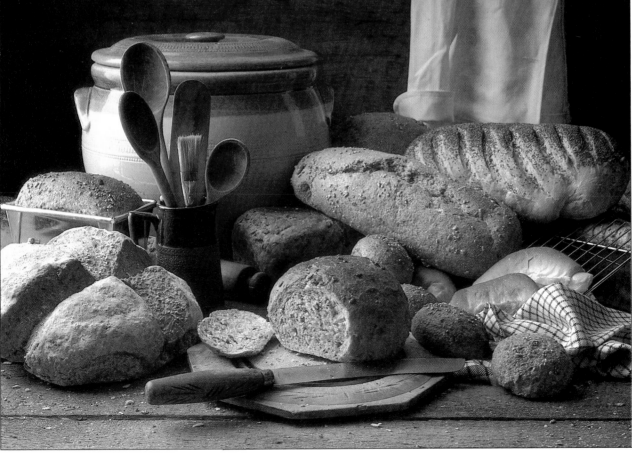

# High contrast

Tone — the interplay of light and shade — is an important element of composition, and can often affect the whole mood of a photograph. For example, part of the impact of the scenes on these two pages comes from the extreme tonal contrasts between the highlights and shadows. Photographic materials, which can record only a limited brightness range, tend to throw such high-contrast scenes into further relief.

Choice of exposure is an important control over apparent contrast. A normal exposure, based on an average between the brightest and darkest areas of a high-contrast subject, will reduce the contrast as far as possible, while losing detail at both ends of the range. If you want to retain high contrast to dramatize a scene, base the exposure on the highlights to leave the shadow areas underexposed.

With a subject such as the magnolia blossoms at the bottom of this page, the contrast of tones was already extreme but could be pushed even further. In a subject with a more even range of tones, you can also use viewpoint and lighting to create high contrast. Strong sidelighting or backlighting both increase contrast. In the picture of windsurfing opposite, the photographer wanted backlighting to bring out the rich colors of the transparent sails, and accepted the fact that high contrast would leave the figures as only dark shapes.

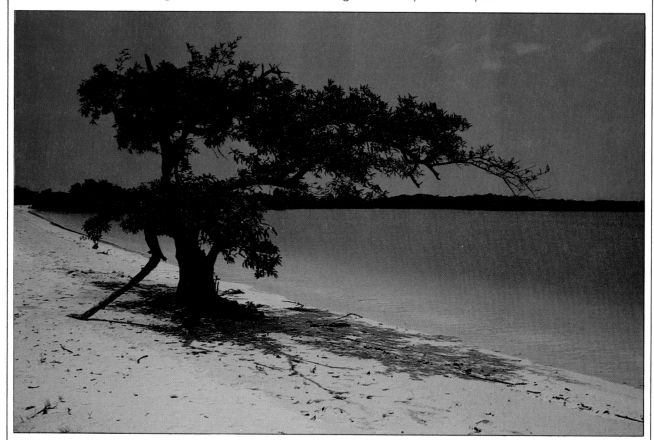

*Bleached sand, contrasted with a vivid seascape and shadowy tree, conveys the shimmering heat of the scene above. The photographer underexposed slightly to retain detail in the light foreground and to strengthen the shadows cast by the tree. The use of a polarizing filter deepened the color of the sky.*

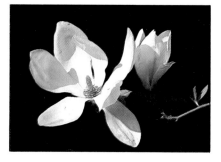

*The creamy purity of blossoms unfurling on a magnolia twig (left) is emphasized against the solid black of the background. The photographer exposed for the highlights to exaggerate this subject's inherent extremes of contrast.*

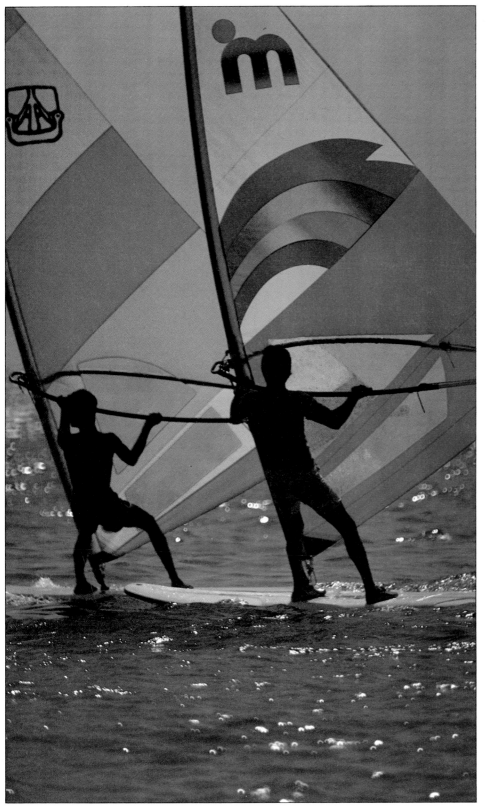

*Two windsurfers are rendered as dramatic silhouettes by a low sun directly behind the sails. Strong backlighting picks out highlights on the water, heightening the contrast. One-stop underexposure has increased the color saturation of the sails.*

# Even tone

Some scenes are naturally even in tone, and others can appear even-toned when weather or light conditions reduce their natural contrast. For example, mist, fog, rain or falling snow can make a whole scene neutral in tone and turn deep colors into attractive pastel tints. Pictures taken in these conditions may lack the drama of those in which contrasts between bright and dark areas are extreme. But by deliberately exploiting low contrast, you can achieve a quieter mood and more subtle beauty, as in the photograph below.

Although you cannot change the weather, you can control other factors that limit the contrast of a photograph. For example, using a reflector to bounce light back into shadows is one way to reduce contrasts of brightness. Putting some diffusing material in front of a light source can also help to cut down contrast in indoor scenes. Such materials can range from a simple handkerchief folded and draped over a flash unit to transparent curtains pulled across a window. A screen will reduce contrast by slightly breaking up the image, as in the picture at bottom right, although an ordinary window screen will tend to introduce an overall grayness rather than the green shade achieved here. Finally you can buy a wide range of filters to reduce contrast. Those called mist or fog-effect filters imitate the kind of neutral tones seen in the foggy picture at top right.

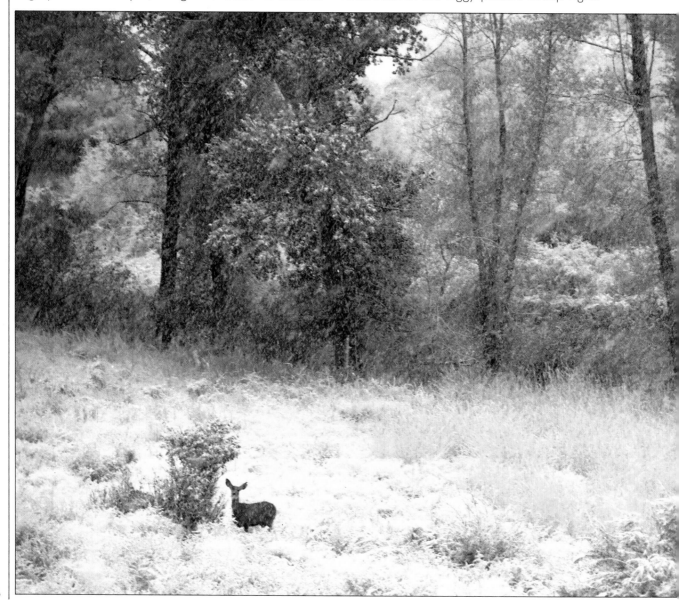

*A foggy day* blankets everything in white, and so transforms a banal view into a ghostly dreamworld (right). The photographer increased exposure by one stop to retain the scene's whiteness.

*A deer* (below) glances at the photographer before bolting. Falling snow softens the harsh tonal contrasts of the winter landscape and seems to fill the picture with quietness.

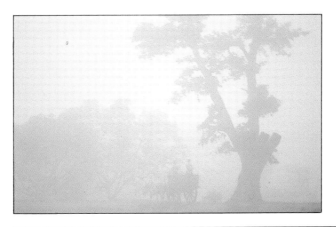

*A green mesh* puts a wash of color across a construction site. The photographer was fascinated by the way the screen suppressed detail and evened out the tones. He used a 105mm telephoto lens to fill the picture with the mesh – actually a safety gate around the builder's hoist.

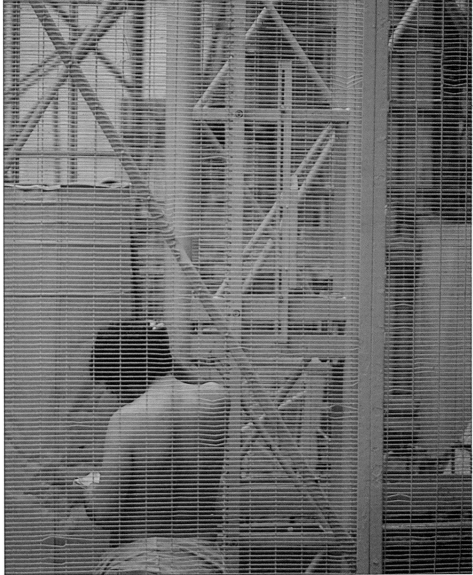

# High key/low key

Most pictures that are low in contrast have a dominant mid-tone – perhaps a shade of gray or a color of average brightness. But sometimes the tones of a scene are predominantly either light or dark, and pictures that reproduce these tones have such a distinctive appearance that they tend to create different moods. Images light in tone are known as high-key, and usually convey a cool, light and airy feeling, whereas low-key pictures have a more somber, even mysterious atmosphere.

Because overexposure lightens tones in a picture and underexposure does the opposite, you can accentuate either mood by controlling the exposure, as the images here and on the following four pages show. But ideally, the tonal key of a picture should be established mainly by the subject and the

lighting conditions themselves. For a high-key picture, the subject should be pale and the light flat or diffused. Indoors, frontal lighting helps to create high-key images by eliminating shadows; outdoors, overcast weather has a similar effect. Because exposure meters will tend to give readings that reduce the brightness of a high-key subject, you may need to allow one or two stops more than the meter indicates. Better yet, take three pictures with progressively more exposure.

In comparison, low-key pictures tend to look more natural because we are more used to seeing dark scenes than intensely light ones. Backlighting, which produces large areas of shadow, offers particularly good opportunities for dramatic low-key images such as the beach scene opposite.

*In high key,* the beach above has a feeling of space and freedom. The damp sand reflects bright but diffused light from the sky. Slight overexposure accentuates the predominantly light tones.

*In low key,* the evening scene feels more gloomy. The photographer faced into a low sun, read the exposure for the highlighted pool of water, and then chose to underexpose slightly.

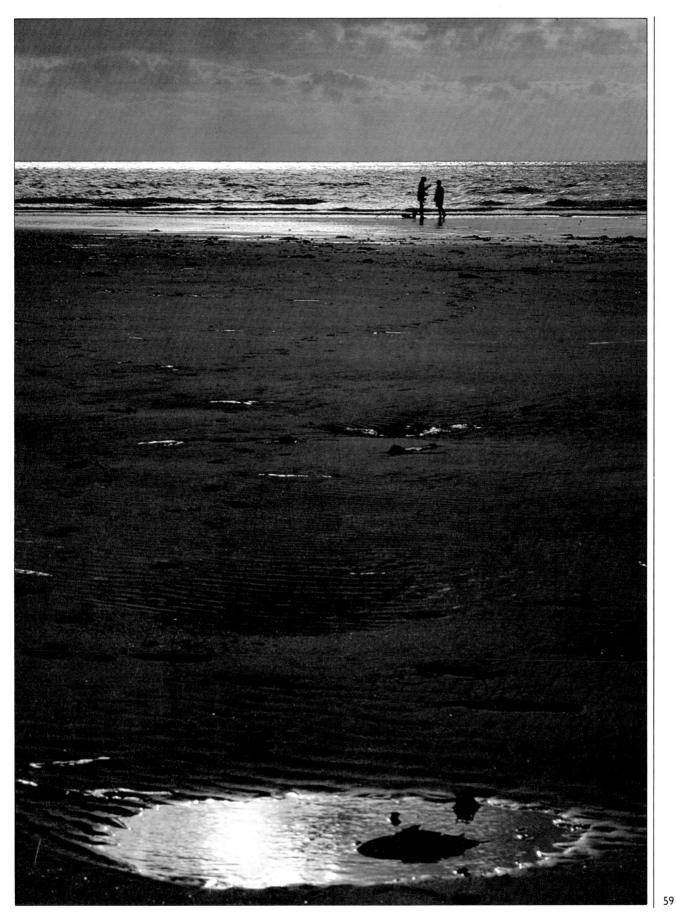

# Overexposure

Overexposure is usually the result of an incorrect meter reading, producing a disappointing picture in which important details have been washed out. But as already discussed, high-key images can be enhanced by slight overexposure; the ethereal beauty of the image opposite is an example of the expressive power of this technique. A theoretically correct exposure reading is not always the best.

Sometimes, overexposure can be equally effective when the subject is not itself high-key but has a full range of tones. The picture below shows how increasing exposure can reveal detail and lighten colors in parts of the subject that a normal exposure might record as dark or even black. The vivid colors at the flower's center would have appeared far more subdued had the flower been correctly exposed.

At the same time, overexposure makes outlines fainter, and can cause them to disappear as they merge with backgrounds of similar tone. Thus the pale petals below become a misty area of white, with no clear indication of where one flower ends and another begins. Similarly, the creative use of overexposure can make the human form lose its precise shape and melt softly into a background. Some areas of darker tone in the subject will help to prevent overexposed pictures from becoming too weak.

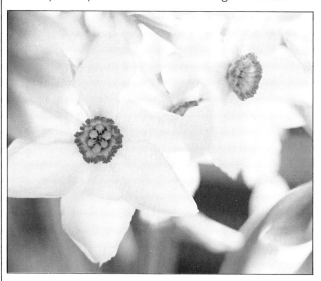

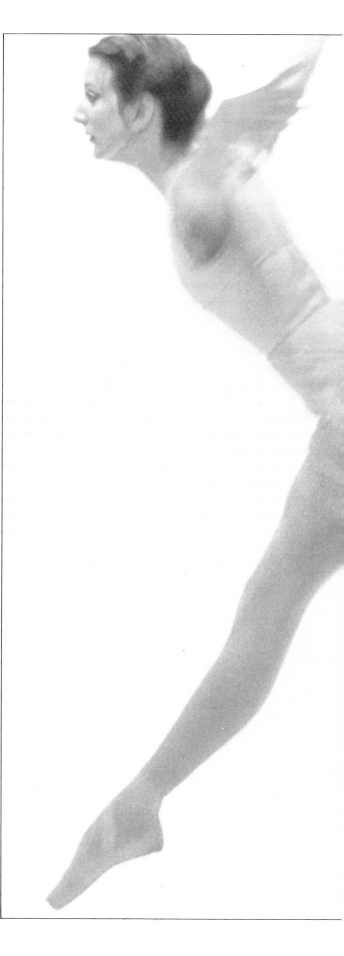

*A bunch of flowers* seems to glow with light in this subtle-hued photograph. The photographer used the even light of an overcast sky to reduce any shadows, and then overexposed by two stops to produce a picture that has some of the pale delicacy of a watercolor painting.

*In graceful motion,* this ballerina seems to be lightly suspended in space. By using deliberate overexposure, the photographer has suppressed the details in the white wall behind the dancer and muted the color of her costume in a way that emphasizes its gauzy, floating quality.

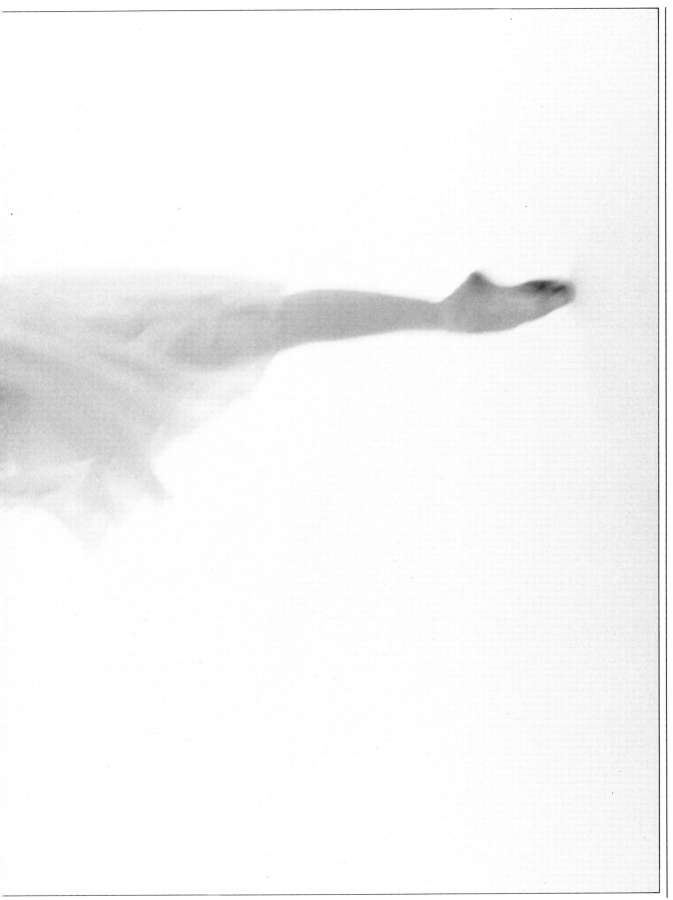

# Underexposure

Whereas an overexposed image tends to convey a gentle, romantic mood, controlled underexposure can create pictures that have a dramatic and sometimes eerie quality.

Usually, underexposure means completely sacrificing detail in shadow areas of the scene you are photographing. But often this is the way we see things in dark places or as the light begins to ebb toward evening. Such lighting conditions have powerful emotional associations, and you can create impressive pictures by exploiting them. For example, to record a townscape at dusk, a normal exposure would seek to retain some detail in the shadows, and the result might be a pale sky with streetlights and windows appearing as colorless highlights. By exposing for the sky itself in the picture below, the photographer turned the evening sky a deep blue, showed the bright color of the artificial lights and created a scene that is charged with atmosphere.

Underexposure can give pictures a feeling of closeness and warmth. With color slide film, the increased richness of colors that are slightly underexposed persuades some photographers to use this technique regularly. But it is better to regard underexposure as a useful technique for situations in which you feel highlight detail is especially important in conveying mood.

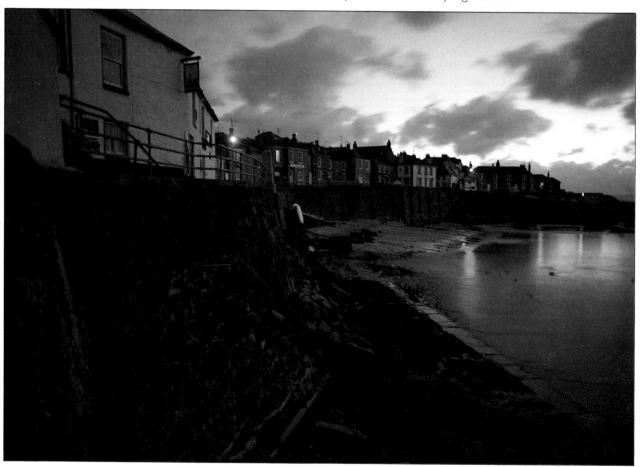

*A fishing village* turns a deep blue in fading evening light. By basing exposure on the sky, the photographer achieved warm colors and left the broad foreground of the picture underexposed to capture a mood of stillness.

*A red jacket* and ghostly blue sails seem to glow in the darkness. Considerable underexposure – two stops – has virtually hidden the background in shadow.

*A baby's toes* enclosed by a mother's hand make an unusual contrast of scale. The tones were darkened by underexposure of one stop, helping to create an image of human warmth and intimacy.

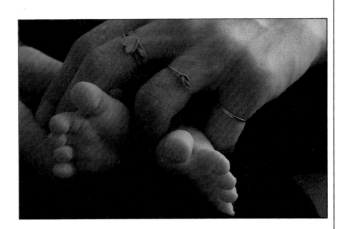

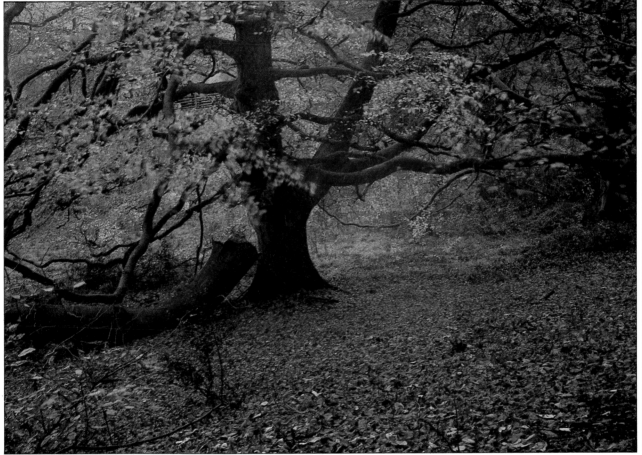

*Autumn leaves* make a rich red-gold carpet beneath a spreading beech tree. Here underexposing by one stop enabled the photographer to retain the color of even the most brightly lit leaf.

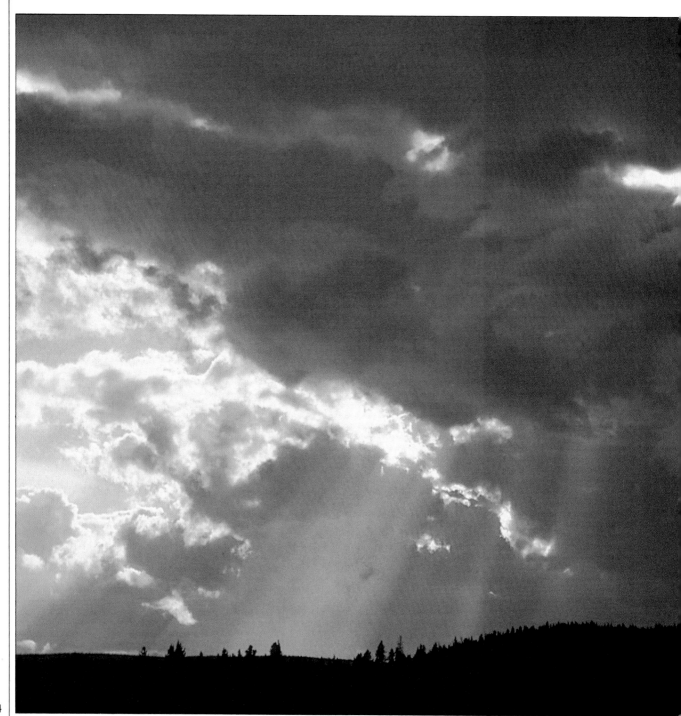

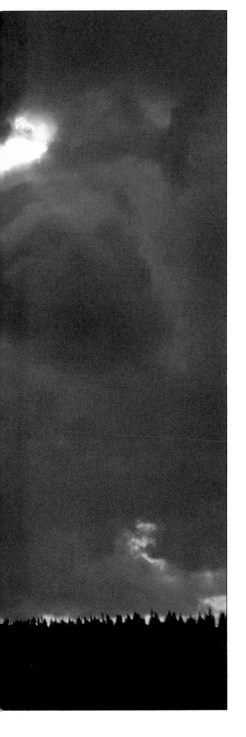

# MAKE LIGHT WORK FOR YOU

The important part played by tone in establishing the mood of pictures shows that the ability to control light is an essential compositional as well as technical skill. To create photographs that have calculated effects, you must be able to use light almost like a tool and know how to vary its quality and direction as well as its quantity.

The following section looks at different types of light and the extent to which you can control them. Outdoors, all photographers face the fundamental problem that the intensity of natural light can produce a range of brightness far beyond anything film can record. You may be able to increase your creative flexibility by a change of camera position or by skillful judgment of exposure. But to get the precise effect you want, you may have to return to the scene at a different time of day, or in different weather conditions, or even at a different season.

Indoors, or at night, photographers have more control over the intensity, duration and direction of the lighting. Some of the most interesting compositions emerge when you begin to introduce extra lights and to experiment with lighting angles. The key to gaining control over light is to try taking pictures under as many conditions as possible. What you may discover is that with increasing experience you can produce good photographs in any kind of light.

*Bursting through clouds,*
*the light sweeps downward*
*in a swathe of silver. By*
*giving one stop less exposure*
*than the camera's meter*
*indicated, the photographer*
*emphasized the pale rays*
*against the blackness of*
*the swirling stormclouds.*

# The natural light of the sun

To make the best use of natural light, you have to know when and why particular lighting conditions prevail, and understand how to turn them to advantage. The sheer power and breadth of the sun's light may seem to restrict the photographer's scope for creative control. But you can influence the picture considerably by choice of exposure, camera viewpoint and, with smaller subjects, the use of diffusers, reflectors or fill-in light. And there is an even simpler way to control natural light: choosing the right moment to take the picture.

Depending on season, weather conditions and the time of day, natural light is infinitely variable in strength, direction, color and quality. The cool, pure light of dawn; slanting sunlight in the morning or afternoon; the dramatic colors of sunset – all these affect the mood and character of an image in distinctive ways. Choosing the best light will depend largely on the subject you wish to photograph and on which facet of that subject you intend to bring out. Perhaps the overall shapes are most important; perhaps you want to reveal forms and textures; or perhaps detail is less important to you than the general atmosphere of the image.

One of the best ways to learn about the varying moods of natural light is to select a single subject near at hand and photograph it at different times of day and on different days. The pictures on these two pages show the sometimes haunting effects that are possible with a simple group of buildings on a city skyline. All were taken from the same west-facing viewpoint, the three smaller images on the same day. But there is a startling difference between the flat, uniform gray tones of the midday picture second from the left and the images at far left and right, both taken as the sun rose.

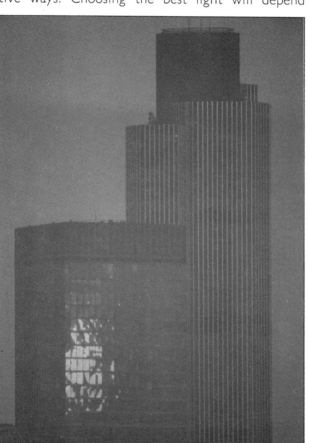

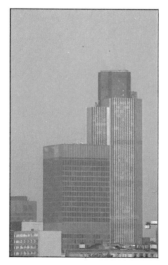

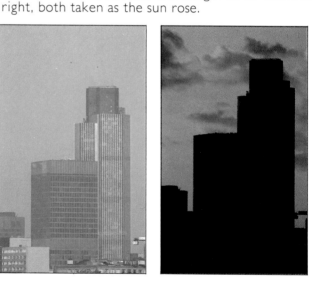

*At noon* on a hazy day *(above), weak, diffused light reveals clear details in the scene. But the uniform tones make a flat, lifeless image.*

*In late afternoon, low backlighting from a cloudy sky reduces the buildings to solid black shapes and apparently unified outlines.*

*Reflections of the rising sun flicker like flames on rows of office windows. In the sky, a bank of mist forms a subtle contrast of hue with the bluish dawn.*

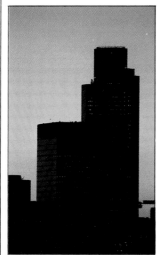

*At sunset* (above) the sky takes on a soft, warm glow, and fluorescent lights shine palely from the windows to define the structures.

*Clear dawn light* striking metal surfaces transforms the architectural lines into columns of gold. This pure, intense light produced the most satisfying image.

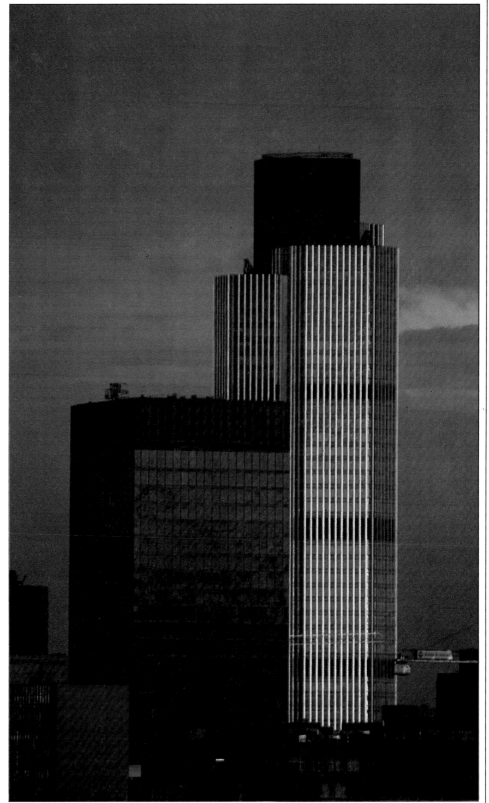

# The exposure you want

Despite all the sophistication of through-the-lens meters, accurate exposure is still technically the most difficult part of photography. Because film can reproduce only a part of the enormous brightness range the eye sees on a sunny day, exposure meters can suggest a setting suitable only for an average of the main tones in the picture. They take no account of the photographer's wish to show clearly all the details in a particular shadow or highlight area.

A useful way to look at a scene is to imagine that a bright sunlit view contains ten main levels of brightness. (One such view is diagrammed at the top of the opposite page.) Different films vary in the brightness range they can handle, but in practice you can assume that the image on the film will show good detail in only five or six of these levels. Parts of the scene beyond these limits will show as entirely dark or light, with no visible detail. Therefore, with high-contrast subjects, you have to decide which parts of the scene you consider most important and adjust the exposure to make sure that they fall within the range of the film. This is a creative decision, and the examples on these two pages show that you often have to sacrifice some of what the eye can see. If the most important detail is in a portion of the subject that is significantly brighter than the rest of the scene, give one or two stops less exposure than that indicated by the average reading, to avoid overexposing this detail. Conversely, if the important detail is in a dark part of a predominantly light scene, increase the metered exposure by one or two stops.

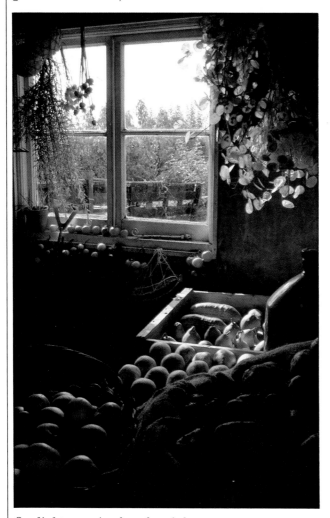

*Sunlight* streaming through a window creates a brightness range too great for the film. Setting exposure for the light area records detail only in the garden.

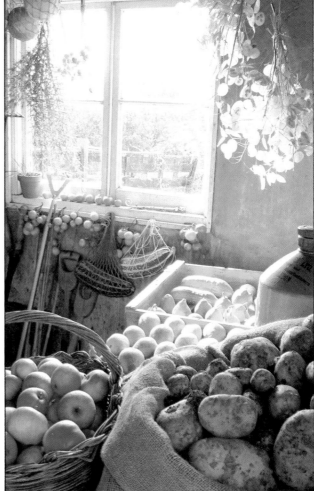

*Giving two stops extra exposure* shows the foreground detail fully, but the highlights around the window are burned out, unbalancing the composition.

*The tonal range* of the scene (above) covers nine out of a possible ten brightness levels – represented diagrammatically by the spots. Because only six of these levels will show good, clear detail on the film, the photographer must select the most important area.

*A simplified tonal range* divides the scene into three main areas: first, the bright garden, then a well lit middle portion and finally the darkest parts of the foreground. This foreground clearly needs some extra exposure for the picture to have visual interest.

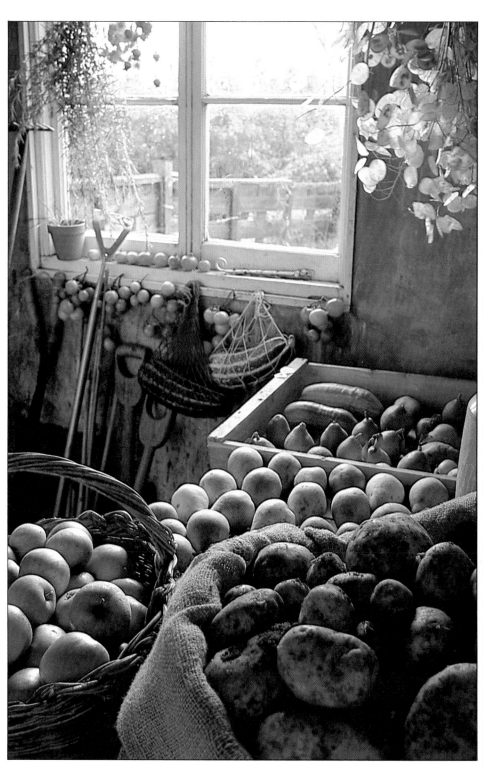

*With one stop more exposure* than the averaged meter reading, the detail in the garden vanishes but the strongest areas of interest show up well.

# Sunlight controlled

Strong sunshine tends to produce such extreme contrast that deep shadows or blank highlights may spoil your pictures, regardless of how well you judge the exposure. But you can radically improve photographs by using simple techniques to modify the light falling on a subject – especially if the subject is of a manageable size.

The simplest way to reduce high contrast is to move the subject into the shade. If you are photographing people in a landscape setting, the shade of a tree will provide a much more even tone on their faces than if they stand in the open. Be careful to take the exposure reading close to the subject so that the meter is not influenced unduly by the bright sunshine beyond. Another technique is to reduce the intensity of the light by rigging up a diffuser between the sun and the subject. For example, if you shield a flower with a piece of translucent paper or

a sheet of thin white cloth, the highlights will be less bright and the shadows softer.

A more practical solution may be to fill in the shadows with flash at reduced power, a technique that can also be used to brighten up subjects posed in the shade, as in the picture below. If your flash does not have a half-power switch, set the ISO rating on the unit at double that of the film in use or, with a manual unit, wrap a double thickness of folded white handkerchief over the flash.

You can also reduce contrast by reflecting natural light back into the shadows. A reflective surface, such as a white wall, acts as an excellent balancing light source. Alternatively, you can introduce special reflectors such as those shown below and in the diagrams on the opposite page – or simply use a hand mirror, carefully angled to reflect a beam of light into a specific area of shadow.

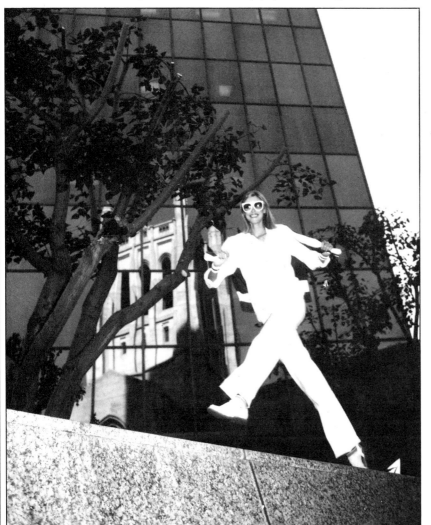

*White clothes gleam brightly in the light from a flash unit in this outdoor fashion picture. The photographer set the exposure for the shaded building behind, then halved the flash power.*

### Special reflectors
You can use any bright, reflective surface to throw light into shadow areas, but portable reflectors are standard equipment for portrait and still-life photography. Several bought or home-made types are shown below. Umbrella reflectors can be folded for transport.

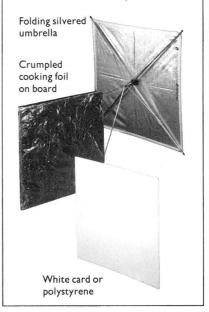

Folding silvered umbrella

Crumpled cooking foil on board

White card or polystyrene

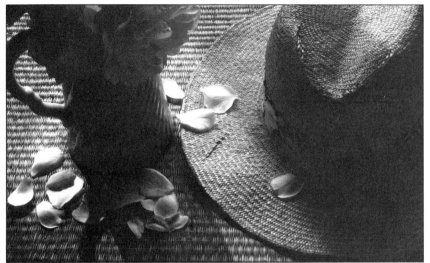

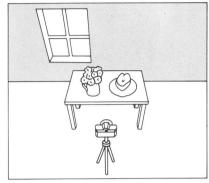

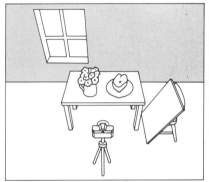

*Daylight from a window* shines
strongly on this informal still-life
arrangement on a basketwork surface,
as diagrammed above. The directional
light shows up shape and texture well.

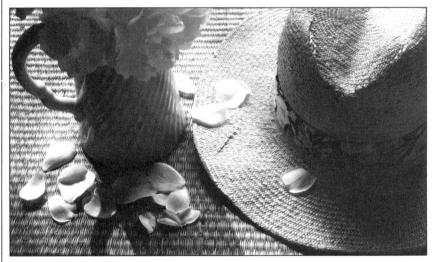

*A large white card,* placed in front
of the subject and to the right, reflects
some light back into the deep shadow
on the hat, adding foreground detail.

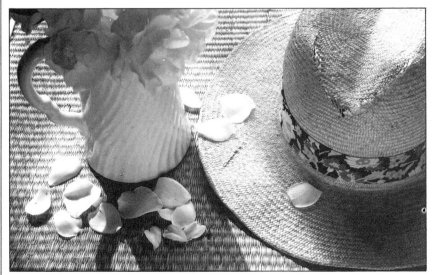

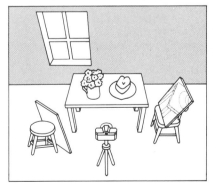

*A large mirror* replacing the card
fills the shadow completely. With the
card moved to the left, the jug is lit as
well, and the emphasis of the picture
shifts to the bright foreground.

# Into the light

Keeping the light source behind the camera almost always guarantees a clear, detailed image. However, to realize the full potential of different subjects, you need to accept the challenge of taking pictures in less conventional lighting conditions. Several of the pictures on these two pages show how you can bring sparkle to otherwise ordinary scenes by photographing into the light.

Backlighting always accentuates shape. A solid object with the sun directly behind will be reduced to a black outline. But if the subject lets some light through, the effect will be quite different. In the picture of the ruined abbey at left below, pale sunlight passing through small gaps between the stones casts a radiating pattern on the grass, yet the con-

trast is low enough for an exposure that also shows clearly the texture of the shadowed walls. With transparent subjects, backlighting can often intensify colors and reveal hidden structures. For example, in the photograph at the bottom of this page, the rimlit red and yellow leaves at the ends of the branches glow with color, while shadows within the lacy pattern of green leaves show the complex structure of the branches.

In strongly backlit scenes, the contrast between bright highlights and dark shadows needs to be taken into account when calculating exposure. As a general rule, if you want to record shadow details clearly, you should take a close-up reading from the most important area.

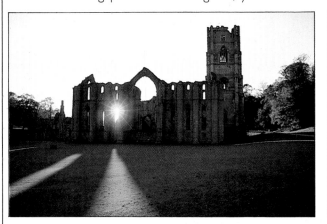

*Coppery backlighting* burnishes the leaves of a plant. The photographer shone a reading lamp on the wall behind the plant and took the picture on daylight film, using a No. 10 red filter to intensify the warm color of the tungsten light. Room lighting reveals some of the decorative detail on the pot.

*Low sun* streaming through a narrow arched window is the dazzling focal point for the image of an ancient abbey, above. Shadows cast by the acutely angled rays create perspective lines that lead the viewer into the picture and convey a sense of depth.

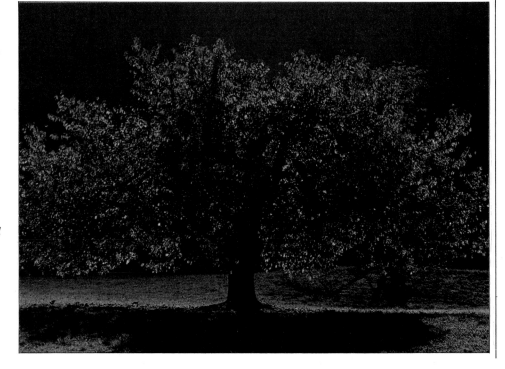

*Strong light* directly behind a spreading tree picks out shapes, patterns and colors against the dark background. The contrast between bright highlights, on the outermost leaves, and solid shadows, where branches and foliage block the light, adds to the impact of the composition.

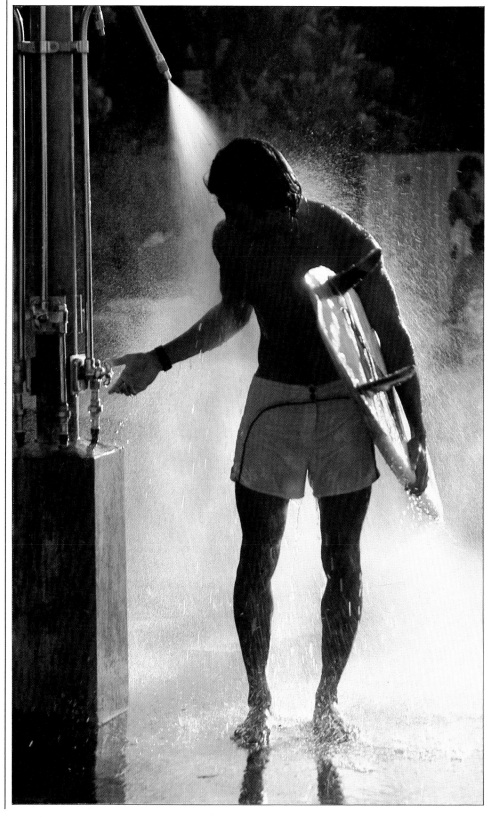

*A fine spray* striking a surfer disperses the sun's rays into thousands of tiny particles, stippling the whole scene with sparkling light. With plenty of reflected light in the shadow areas, the photographer based exposure on an average reading.

# Raking light

Many photographers are wary of taking photographs in bright sun because of the problems of contrast. But at the right time of day, clear sunlight offers marvelous photographic opportunities.

In midmorning, and again in the afternoon and early evening, the low sun sends oblique shafts of light across a scene, picking out textural details that are lost in broader light. As the position of the sun moves more to the side of the subject, shadows become larger and longer. Yet because the light is less intense than at midday, these shadows are soft-edged rather than harsh. This sets up a subtle play of light and shade often exploited by landscape photographers to give modeling and depth, as in the pastoral scene opposite. You can use the same lighting effect to give drama and atmosphere to any subject. Viewed from the side, a figure facing a low-angled sun will be outlined with a golden light that appears both warm and flattering. The profiled girl at far right is an example.

Going out with a camera and observing how the colors, forms and moods of a scene change according to the sun's position is by far the best way to discover lighting effects. Sometimes, returning to your subject an hour later can make a surprising difference. But you do not always have to wait for the sun to move. To get the striking picture at the bottom of this page, the photographer changed his viewpoint by walking around the corner of the block and took the second picture with the slanting sunlight falling across the subject.

**Moving the camera**
Altering the direction of the light resulted in two very different images of the same subject (right). Harsh frontal lighting registered the old man, the plants and the wrought-iron balcony in equally sharp detail (1). By walking around the corner, the photographer got a far more atmospheric view (2). Bright sunlight from one side casts a halo around the man's white hair and transforms the ornate metalwork into glittering silver filigree.

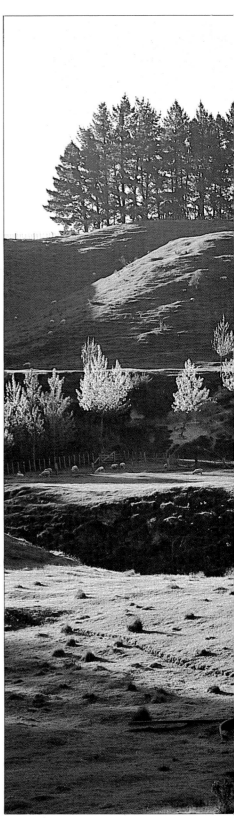

1
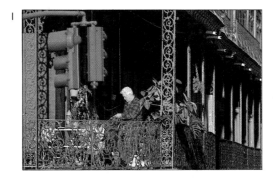

2
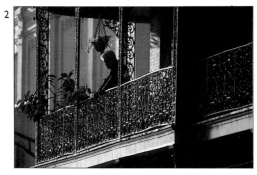

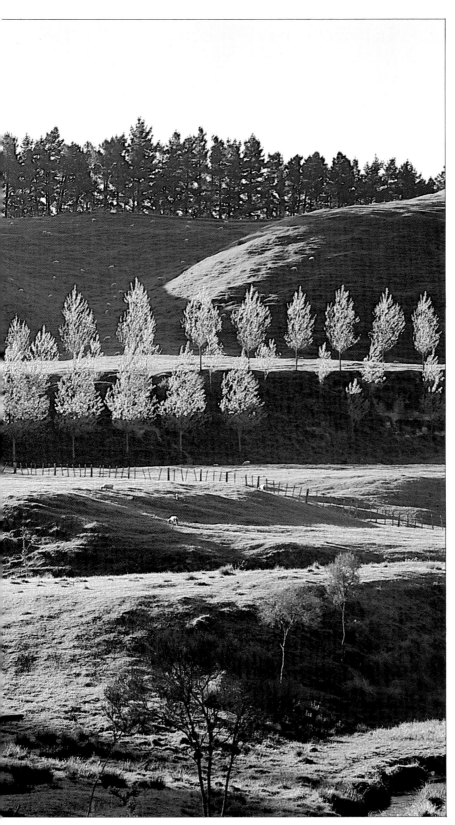

**Low evening sun** *rakes across a hilly landscape dotted with sheep. The lengthy shadows cast at this time on a bright day, together with the warmth and clarity of the light, are perfect for bringing out form and texture in such scenes. Here, sunlight catching the poplars makes an interesting contrast with the dark line of firs standing high on the horizon.*

**Oblique rays** *from late afternoon sun skate over a craggy rock and gently gild the profile of a girl gazing out to sea. Light reflected off the sand and water creates a hazy background that adds to the strong romantic mood of the picture.*

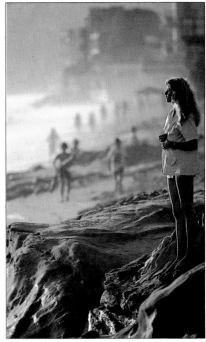

# Hidden sunlight

When clouds or haze cover the sky, the sun's rays scatter and lose some of their intense directional power to create bright highlights and dark shadows. But at the same time the area of the light source increases, as the light from the sun's relatively small surface spreads across the whole of the sky. The clouds act as a vast, translucent screen, and the result is reduced contrast and lighter shadows.

For many subjects this is the ideal light, and you should take advantage of it. Colors will appear at full saturation, bright and rich, as in the remarkable picture of rock formations opposite, revealed in sharp detail by a strong but shadowless light. You will have maximum flexibility in these conditions, for the contrast range will be within the scope of the film, and the good light levels will allow the full range of shutter speeds and apertures to be used.

In hazy sunshine or with light clouds, the sun's light is still sufficiently bright and directional to cast clear shadows and convey the impression of rounded form and subtle textures. Opportunities become more limited as the clouds thicken. Of course, breaks in the clouds can provide some of the most dramatic effects of all as shafts of light strike suddenly through massive cloud formations. But when the cloud cover seems impenetrable, reduced light levels produce too little contrast and give photographs a flat quality. You may need to look for subjects that have a pale, monochrome beauty, and frame them so as to include strong shapes of lighter or darker tone to give some form to the image.

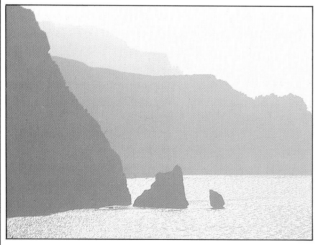

*A rocky coastline (above) stands out from the shrouding gloom of mist and low clouds. The photographer chose the strongest contrast – dark rocks and reflective sea – and exposed at 1/30, f/4, with ISO 64 film.*

*Multicolored rocks have a painted clarity in the diffused light of an overcast day. The photographer exploited the even lighting for a composition of bold color shapes – subtly hued stone contrasting with somber trees.*

# Morning and evening light

The crisp light of morning has special qualities, and anyone prepared to rise at dawn will discover that pictures taken at this time have a distinctive atmosphere. When the sun appears on the horizon, the sky fills with a pale, red-tinged light that mingles with the blue hues of the night sky, the whole effect frequently softened by early morning mists. On film, this can produce the kind of subtle pinks and blues of the picture at the top of the opposite page.

After the morning mist has cleared, the landscape is free of the heat haze that can obscure distant views, and of the traffic and crowds that may clutter pictures taken later in the day. Low sunlight reveals this clarity and emptiness without introducing harsh contrasts of light and shade.

As the day draws to a close, the sun is again low on the horizon, although the accumulation of dust and heat from the afternoon means that the light does not have the crystal-clear sharpness of dawn. However, its warmth and softness make the evening a good time to take portraits. In the mellow light of sunset, faces take on an attractive glow, as in the bottom picture on the opposite page. Alternatively, to achieve more accurate skin tones, you can correct this warm cast by using a No. 80C blue filter.

The beauty of a sunset or sunrise can seem to linger, but in reality passes quickly. The sun touches the horizon for only a matter of minutes, and if you want to take more than a handful of images of the setting and rising sun, you must work quickly. For example, the sun disappeared just seconds after the photographer took the picture directly below.

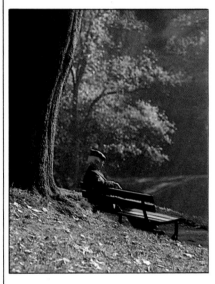

*Resting on a bench, this early riser enjoys the thin warmth of the sunlight on a fall morning. The bluish-green colors of the shadowed trees in the background suggest the crisp atmosphere typical of the season and the time of day.*

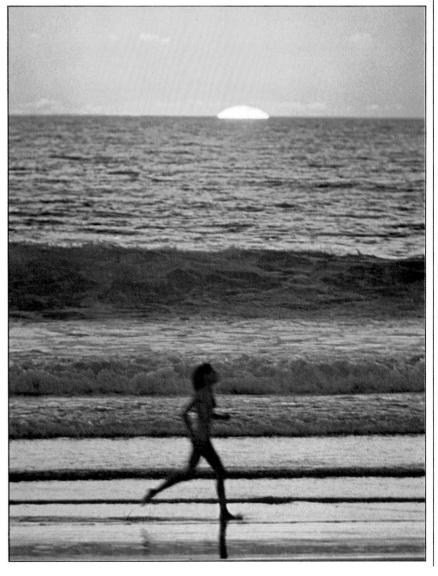

*The sinking sun warms a late runner, whose silhouette adds a sense of movement and interest to what might otherwise be a static, conventional sunset photograph. Because the rising and setting sun cause strong backlighting, always try to include a foreground element that produces an effective outline, as does this figure.*

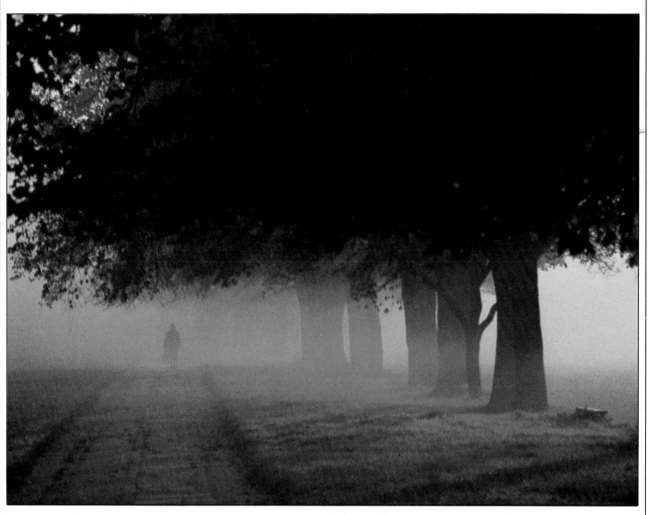

**A procession of trees** seems to
follow this figure through morning
mist. The sunlight shining between the
trees casts soft shadows that emphasize
the receding planes of the picture.

**A young woman's face** picks up the
glow of sunset. Because the sun had lost
much of its intensity, she was able to
look directly toward the light without
discomfort or squinting. This direct
frontal lighting gives the portrait an
unusual brilliance.

79

# Moods of artificial light

Photography indoors or under artificial lights can produce pictures of many moods, from the theatrical effects of spotlighting to the most subtle interplay of soft light and shade in a room interior. Often the most interesting and atmospheric approach is simply to make use of whatever light is available.

Of course electric light is much dimmer than sunlight, and usually a different color as well. One way to deal with the low intensity of available light indoors is to use fast film and a wide aperture. With VR1000 print film in the camera, you should be able to set a shutter speed fast enough for a handheld picture in all but the dimmest interiors.

If a meter reading indicates that the light is still too dim, try to bring the light source and the subject closer together, so that you need expose only for the brighter parts of the scene. To get the picture at right below, the photographer preset exposure for the area close to a spotlight and waited for the leather-clad couple to walk into the lighted area. Although pictures taken in this way have harsh contrasts with surrounding details hidden in deep shadow, such dark areas do not look unnatural. Often they add drama, and you can always reduce their size by close framing.

On slide film, the light from household bulbs appears as a distinctive orange color. Sometimes pictures with this orange cast have their own special appeal, as shown here, but if you want to restore natural color rendering, you should use a film specially balanced for tungsten light or fit a No. 80C blue filter over the lens.

*The carousel lights* were strong so the photographer decided to avoid using flash, to retain the atmosphere of the fairground. He took the picture before the ride started to move (ISO 400 film: 1/30 at f/2.8).

*An artist's room* glows with light. By switching on every available table lamp, the photographer was able to illuminate evenly each intricate detail of the room (ISO 400: 1/30 at f/4).

*A spotlight* catches two stage performers in its harsh beam. Even lighting and true-to-life colors rarely help in such pictures, which depend strongly on mood (ISO 200: 1/60 at f/2).

*A library* brightly lit by fluorescent tubes presents few exposure problems. But the color of fluorescent light can be unpredictable. With slide film, and in less well lit interiors, a red or magenta color correction filter is useful to avoid green casts from certain types of fluorescent bulbs (ISO 200: 1/30 at f/2.8).

# Artificial light controlled

Although available artificial light is often the most satisfactory for indoor photography, you can control the light in a much more creative way if you introduce your own lights to the scene. Such lights need not be elaborate. For each of the pictures shown here, the photographer used only one light source. Nor does indoor lighting have to look completely natural; sometimes a picture's impact depends on the unusual way that the light falls on the subject.

The most obvious source of extra light is a flash unit. However, because of the short duration of the flash, it is impossible to see how the light will fall before you take the picture. This means that a flash on its own is difficult to use in a controlled way. You can try placing an adjustable household lamp alongside the flash unit so that both shine at a similar angle. For a picture like the one below, this will approximate the effect of an angled flash.

More precise control of the image is possible if you use photolamps. These look like ordinary light bulbs, but they give out much more light because they burn at a higher temperature. Thus, for maximum safety, use them only in the ceramic sockets of lampholders designed specifically for photolamps.

Such holders are quite inexpensive, and are supplied with adjustable stands, so that you can position the lamp exactly where you want.

In addition to providing stronger light than household bulbs, photolamps produce a bluer light. Nevertheless, the light is still more yellow in color than natural daylight, and if you use photolamps with regular slide film you will need to fit a No. 80A blue filter over the lens to correct the yellow cast. But if the film is balanced for tungsten light, a scene lit by photolamps will appear in natural hues, as does the apple at bottom right.

*The striking portrait* at left shows creative use of a flash unit. The photographer angled the unit up from the floor at the right to cast the strange shadows.

*Shiny legs* glitter in the light of a single photolamp. By fitting the lamp into an adjustable holder, you can easily reposition it to find the most effective lighting.

*A green apple* forms the simplest of still-lifes. The photographer placed the apple on glass backed by a green card, and used a single photolamp to the right.

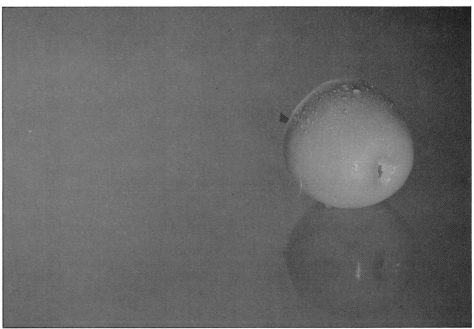

# Mixing different kinds of light

When light levels are low, in the evening, at night or indoors, many photographers mistakenly put their cameras away or else take pictures exclusively with a flash. Yet the available light – twilight, moonlight and the numerous forms of artificial lighting – is not only adequate for photography but also results in some of the most exciting compositions of all. This is as true of large interiors, such as the Greek church on the opposite page, as of outdoor scenes.

When taking pictures at night, remember that the available light sources are unlikely to have enough power to act as conventional lighting. Try thinking of the lights themselves as the main subject of the picture. The best time for night photography in cities is the early evening, when enough light remains in the sky to give shape to silhouetted buildings. Windows, illuminated signs and streetlights will provide a blaze of contrasting colors. Take the exposure reading from a light sky. The picture will then be dark overall, with the individual lights appearing as bright highlights. In scenes including a mixture of tungsten lights, fluorescent lights, neon signs and car head or tail lights – all of differing colors and intensities – there is no such thing as accurate exposure. Use the meter reading as a general guide, then try giving one or two stops more and less in bracketed exposures. A starting point for a city scene such as the one at near right could be 1/2 at f/2 with ISO 200 film. You will have to use a tripod to avoid camera shake. Look for bold compositions, with strong shapes to provide a framework for the myriad of smaller lights.

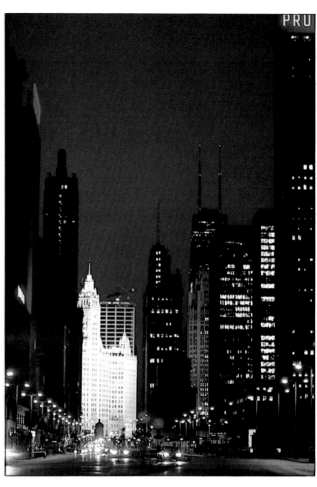

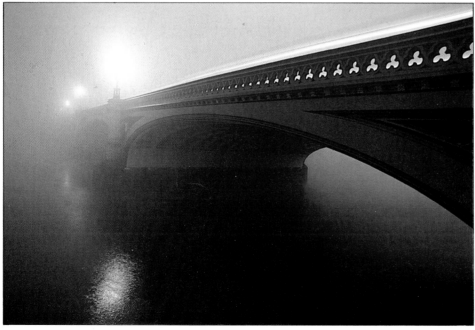

*Chicago by night* (*above*) glitters with multicolored light from buildings, cars, streets and signs. Twilight gives shape to the skyline (*ISO 200: 1/8 at f/2*).

*Shrouded in mist,* a bridge (*left*) stretches away into the mysterious, eerie glow of the streetlights. An exposure of one second flooded the picture with light and showed the lights of the passing cars as elongated streaks.

*A church interior* (*right*) is filled with light, the orange of the candles and tungsten lightbulbs predominating. Rays of daylight from the high windows look white (*ISO 64: 1 sec at f/5.6*).

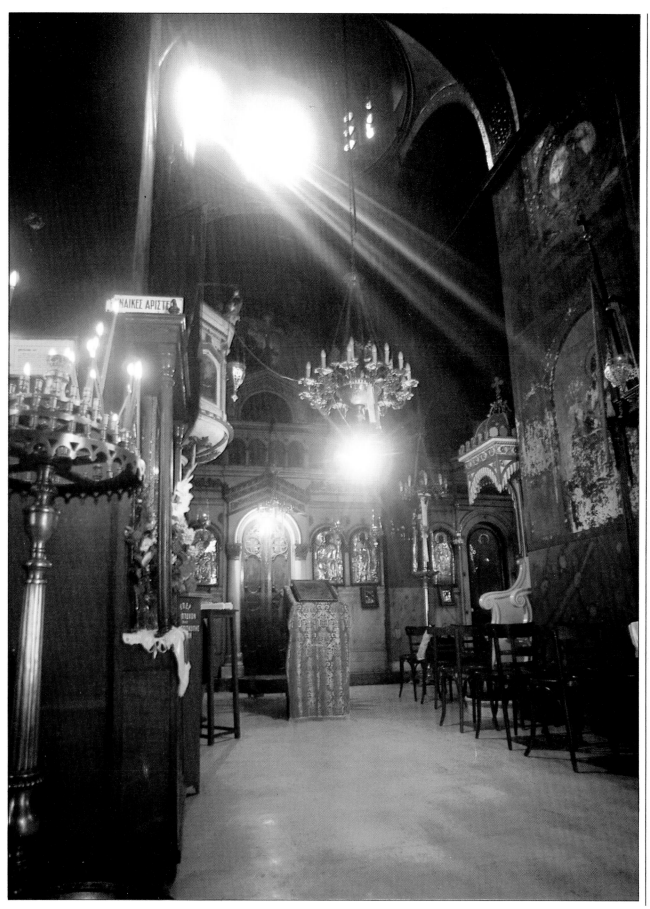

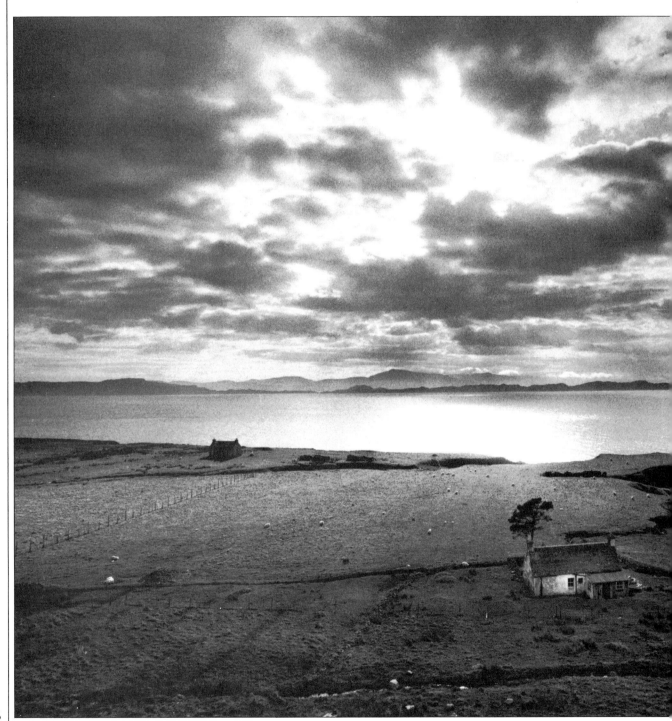

# USING SPACE
# AND DEPTH

The landscape at left draws the eye inward so strongly that you can easily imagine yourself walking forward to the water's edge. It is precisely this sense of space and depth that gives the final stamp of realism to many pictures.

A number of factors can contribute to the effect of depth and space in photographs. Variations in light and shade give individual objects an appearance of solidity; overlapping forms show that one lies behind another; the dwindling sizes of objects indicate that some are more distant than others; converging lines strengthen the effect of perspective recession; and softened tones, colors or outlines suggest the haziness of a distant view. In addition, photographs often have a restricted depth of field, so that parts of the picture at different distances are distinguished from one another by variations in the sharpness of focus. The pages that follow look at all these perspective effects and show how you can use them, alone or in combination to make pictures look three dimensional.

*A vast expanse of land and sea stretches away into the distance, the foreground dotted with cabins and sheep, the horizon ringed with hills. The use of a wide-angle lens has dramatically emphasized the sense of the majesty of space by extending the sky toward the viewer and also far back, seemingly beyond the surface of the picture.*

# Framing the subject

An immediate way of suggesting depth in a picture is to use some element in a scene to act as a foreground or middle-distance frame overlapping part of the main subject. This technique of creating a frame within the frame of the viewfinder itself helps to concentrate attention on the main subject – as do the trees below, framing a white church. Often, the frame can also hide unwanted details or enliven a picture by adding contrasting tones or colors to an otherwise uniform scene.

Finding a frame for a subject is often just a matter of moving the camera until something suitable appears in the viewfinder. An arch, rocks on a shore or an overhanging branch are all useful framing devices. Generally, a foreground frame should be darker than the subject. This lessens the risk of distraction and helps to lead the eye forward into the picture. Another way to ensure that the frame remains a secondary element is to set a wide aperture, and focus on the subject so that the shallow depth of field leaves the foreground out of focus, as in the picture at the bottom of this page.

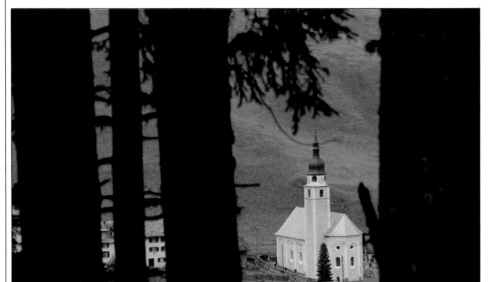

*Tall, straight trunks* of evergreens frame a country church. The dark foreground tones and the light-colored building together convey a powerful sense of depth.

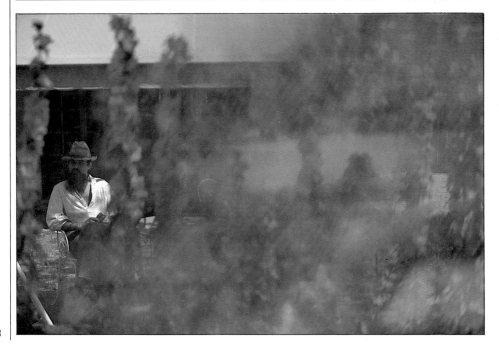

*Blurred reflections* of flowers, photographed with a wide aperture of $f/2$, frame a sharply focused figure relaxing on the terrace of a restaurant. The stronger definition of the flower on the left helps the eye to rest on the main point of interest and not stray out of the picture.

*A locomotive shed* creates a picture within a picture. Plain surroundings, made bluish by a magenta filter, intensify the warmth and color of the enclosed scene.

# The lead-in

Images appear most convincingly three-dimensional when they contain a foreground, a middle distance and a background. Using foreground elements to pull the viewer into the frame toward a central point is a powerful means of conveying distance, space and depth in a picture.

Sometimes a feature within a scene provides an obvious lead-in. A road or river stretching back into the distance will draw the eye into the scene, especially if such a lead-in starts in the near foreground or at the sides of the picture. You can exaggerate, or even create, a lead-in by choice of viewpoint. By including the bench in the picture below, the photographer strengthened the strong diagonal lines that impel the eye down the avenue. A wide-angle lens, which allows you to include more foreground details in close-up, will accentuate the lead-in effect in subjects such as this. When a scene contains no obvious feature to lead the eye into the picture, you may be able to suggest one by means of highlights or shadows. The interesting double-image effect on the opposite page is a fine example.

*Long, bold shadows* cast by late sun create an unusual lead-in. Often the strong patterns of such overhead views tend to look flat.

*A tree-lined walk* crisply etched in the snow seems to recede almost to infinity. The footprints and bench in the foreground begin the effect.

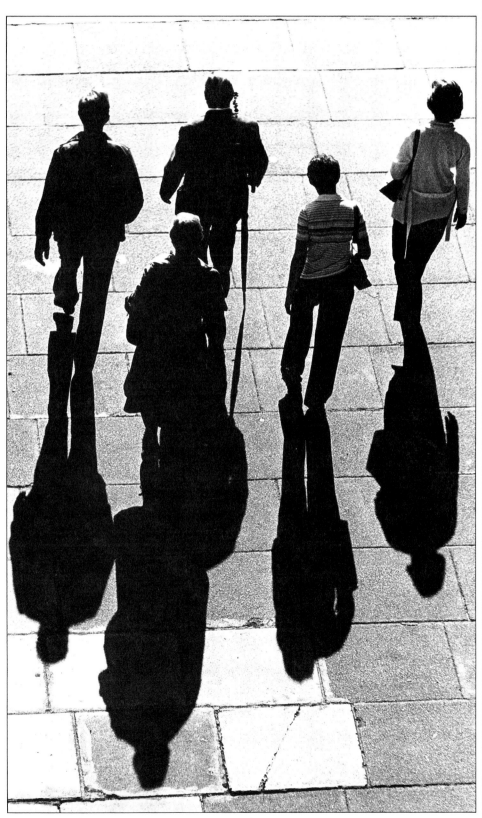

# Focus to control depth

Usually, the purpose of focusing is to ensure sharp detail in an image. But the capacity of a camera lens to render parts of a scene out of focus can provide a valuable control over composition. By modifying depth of field with different apertures, you can exaggerate or suppress a photograph's feeling of depth.

The picture at left below shows how effective differential focusing can be. The shallow depth of field provided by a wide aperture limits the zone of sharp focus to a few centimeters. Muted color in the background emphasizes the separate planes without overwhelming the delicate hues of the flowers. To concentrate attention on a more distant subject, you can use a smaller aperture but move so close to a foreground detail that it appears out of focus. In the architectural picture opposite, the photographer made use of the blurred geraniums both to suggest

depth and to enliven the image with splashes of brilliant color.

These techniques are useful when you want to single out a subject on one plane and show elements in front or behind in less detail. However, some pictures rely on overall sharpness for their impact. You can achieve this clarity, without sacrificing a sense of depth and distance, by using a wide-angle lens, as in the photograph at the bottom of the opposite page. As well as extending the range of sharp focus, this has the effect of making objects near the lens appear larger in relation to the elements behind. If, instead, you wish to minimize depth and distance, you can use a long lens at a small aperture – as in the whimsical image at right below. Because a telephoto lens has shown a flattened perspective, the cars seem almost stacked on top of one another.

*Zones of varying sharpness give a sense of spaciousness to a small temple interior. An aperture of f/2 recorded only the foreground vase of flowers in sharp detail. The doors provide echoes of the same color and a frame for the soft blur of the scene beyond.*

*Cars zigzagging down a road flanked by terraced gardens seem to be emerging from the flower beds. The photographer used a long lens at an aperture of f/16 to compress distance and record the whole scene with equal sharpness, so that the steepness of the slope seems exaggerated.*

**The grand scale** of the architecture at left attracted the photographer. To give full prominence to the line of arches stretching into the distance, he chose a small aperture for maximum depth of field and closed in on the foreground flowers to throw them out of focus.

**Extended focus** suggests the broad, lonely setting of this rural scene. By using a wide-angle lens, the photographer increased depth of field and exaggerated the contrasts in scale. As a result, the picture has a feeling of space although the viewpoint does not show the distance.

# Scale and depth

Focusing and framing can help to give an impression of three-dimensional space to a picture, but variations in the sizes of nearby and distant objects in the photograph provide an even more compelling sense of depth. This is because judgments of distance in real life are based largely on the apparent differences in size between near and far objects. When a row of similar objects stretches away into the distance, as do the boats in the picture on the opposite page, the nearest one always looks bigger than the farthest, although we know from experience that the boats are actually very similar. Thus, the diminishing sizes of the boats provide a fairly accurate indication of the distances between them.

Scale relationships convey a clear impression of depth even when objects in a picture are of very different sizes. For example, in the picture at near right, the cat looms as large in the frame as does any figure in the background. But knowing the usual sizes of cats and people, the viewer assumes not that the cat is gigantic but that the background figures are farther from the camera.

Including a foreground object in the frame is a particularly useful way of giving depth to a picture when the main subject is rather flat. The photograph below of the facade of Notre Dame Cathedral would have looked much less three-dimensional without the bracket of lights in the foreground. A wide-angle lens can strengthen the illusion of depth in a photograph by letting you move in close so that a foreground object appears larger than normal in relation to the background.

*A cat in a train station* is the focus above. Using a normal lens from a low viewpoint, the photographer was able to include in the background the diminishing figures of passengers, and thus give a sense of depth.

*Parisian streetlights* (left) in front of Notre Dame Cathedral add depth to the picture. The photographer used a 28mm lens, close to the lights so that their scale made the massive facade seem more delicate.

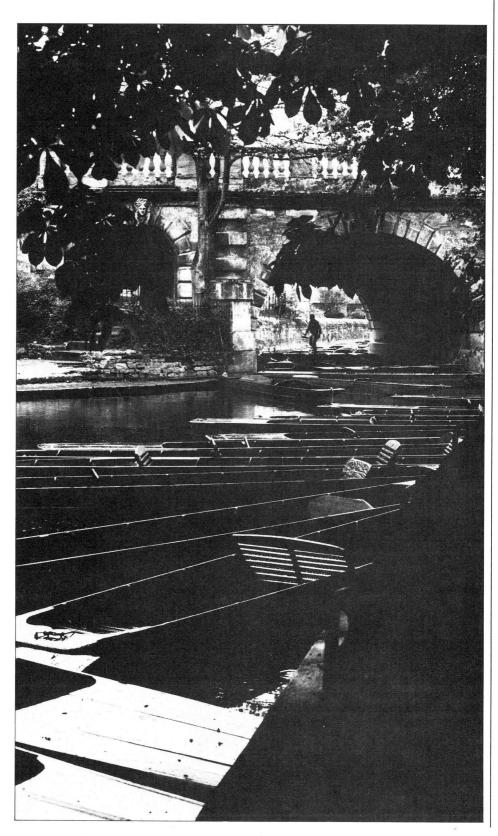

*Pleasure boats* wait for people in a shady backwater. By using a wide-angle lens, the photographer produced a strong effect of receding space as the dwindling size of the boats helps to draw the viewer's eye back to the figure under the bridge.

# Adding a sense of scale

By taking a small segment out of a larger scene, a photographer may remove any clue to the size or distance of an object within the frame. Sometimes you can exploit this effect deliberately, but more often you will need to find some way to re-establish depth and scale. An object of familiar scale may convey the missing information, as does the basket in the picture of giant mushrooms on the right. Including a human figure – or perhaps even a hand – establishes scale even more effectively. Without the figure in the photograph at left below, the brightly colored blocks might seem only inches tall. A child can provide a particularly dramatic contrast when the main subject is unusually large, as in the picture on the opposite page.

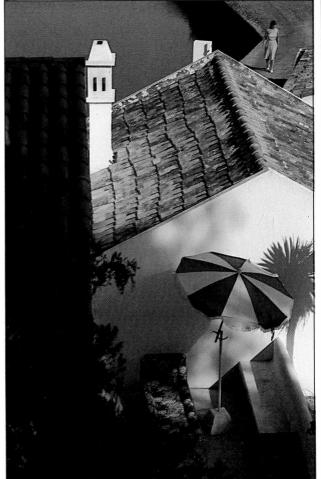

*A modern sculpture might look like a child's toy except for the figure. Such overhead viewpoints tend to show few clues to the scale of objects.*

*A lone stroller gives this picture distance and depth, and compensates for the flattening of perspective caused by a telephoto lens.*

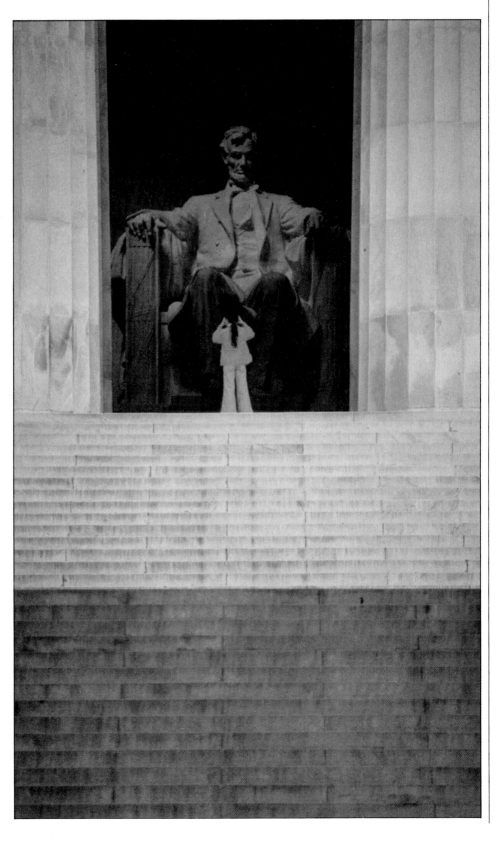

*A wicker basket* (left) indicates the size of these big parasol mushrooms. A photograph of them growing, or lying in a pile on the dew-soaked grass, would have given little sense of their true scale.

*Lincoln's statue* looks down at this youngster from an awesome height. By ignoring passing adults and waiting for a brightly dressed child to confront the statesman's stony gaze, the photographer was able to convey the larger-than-life proportions of the statue even more effectively.

# Linear perspective

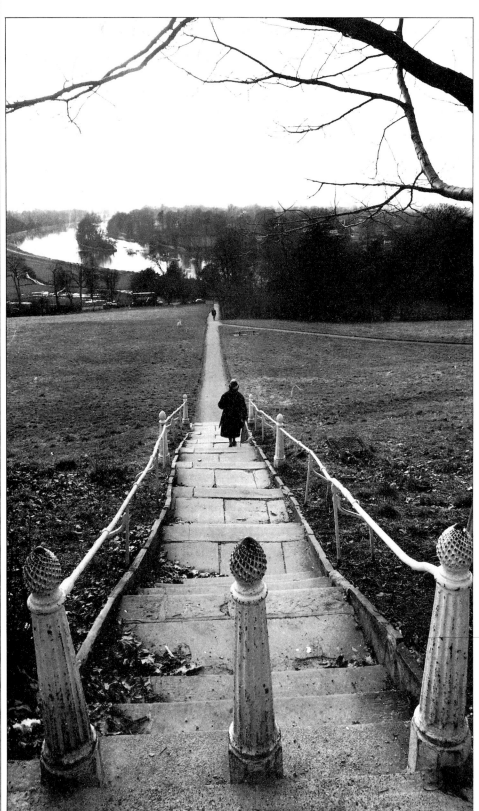

*Steps and iron railings* pull the eye forward with the walking figures in this winter scene. By composing the photograph so that the converging lines of the path lead straight away from the camera, the photographer achieves enormous depth. The river winding into the far distance takes up and continues the perspective.

*An inquisitive mule* (right) spearheads dual perspectives. By moving in close to the fence with a 24 mm wide-angle lens, the photographer was able to exaggerate the angle at which the fence bars run toward two distant vanishing points. This viewpoint also makes the mule's head appear to be so large that its muzzle almost seems to protrude from the picture.

*A cathedral* nave shows
that linear perspective in
buildings can be as powerful
overhead as on the ground.
Here, converging lines lead
irresistibly to the altar.

Parallel lines leading away from the camera always appear to converge, as in the picture of the path on the opposite page. This effect, known as linear perspective, often produces a stronger impression of depth and distance than does any other visual element in a photograph. Viewpoint can help to emphasize the effect, because the lines seem to come together most rapidly when you see them from close up. Thus, railroad tracks appear to converge more sharply when you look along them from ground level than when you see them from a bridge above the tracks. Using a wide-angle lens can dramatize this kind of linear perspective.

Converging lines will eventually meet at a vanishing point. Depending on the scene and the viewpoint, this may be outside the frame of the picture or inside it, on a distant horizon. If two sets of parallel lines appear in the photograph, running at an angle to each other, there may even be two vanishing points. In the strange picture of a mule in a paddock, below, the bars of the fence meet at an acute angle, so that you can see lines leading off toward two vanishing points, and the image has a redoubled sense of perspective as a result, producing a strong sense of depth.

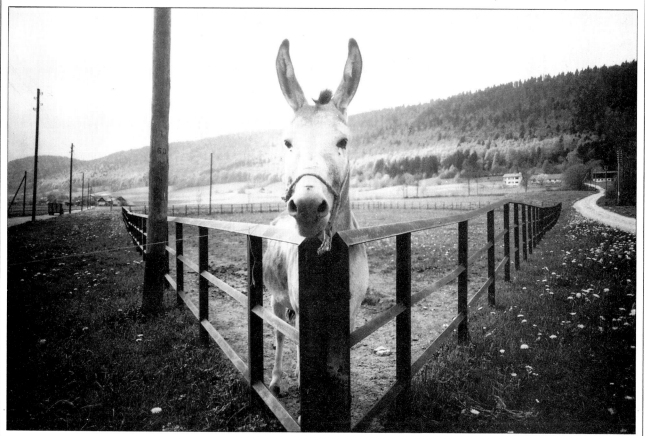

# Haze and distance

In most landscape photographs, the atmosphere itself can create a powerful illusion of depth and distance, even in the absence of other perspective devices. This is because on all but the clearest days, particles of smoke, dust and water vapor float in the air and cast a thin veil over the landscape. Light haze or mist makes very little difference when a subject is close to the camera, but the effect of atmosphere increases with distance to soften, lighten and diffuse the tones and colors of far-off parts of the scene. This way of suggesting depth is called atmospheric perspective, and you can see its progressive results very clearly in the photograph below at left. Each successive hill is paler than the one before, giving the image a wonderful sense of almost limitless distance and recession.

Whereas a wide-angle lens exaggerates the effect of linear perspective, it shows atmospheric perspective less clearly, by diminishing the distant part of the scene. A telephoto lens, on the other hand, enlarges the distant scene and seems to compress the receding subject planes, so that the difference in tone between each of them is more marked.

You can also enhance atmospheric perspective if you compose the picture to include some sharp, well-defined features in the foreground. This ensures that there is a strong tonal contrast with the paler and less distinct background, as in the picture below at right. If you are using color film, a pale blue filter such as a No. 80C will also emphasize haze in the atmosphere and increase the effect of distance by making the picture bluer and lighter overall.

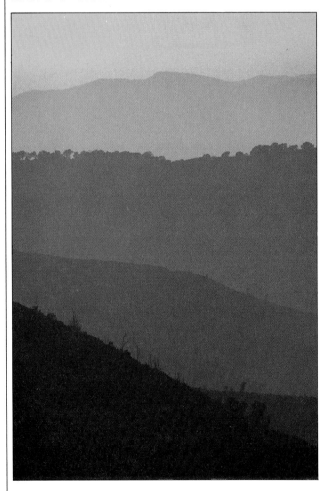

*Ridges fade in softening bluish tones toward a far distant sunset sky. Rising mist provides perspective although the hills appear otherwise as flat shapes.*

*Frosted trees frame a faintly outlined cathedral. Even the clear, wintry air carried enough water vapor to give the more distant details atmospheric softness.*

*A farmer plows in the lee of a castle. By using a 200 mm lens from a distance, the photographer increased the intervening mist – and the picture's atmosphere.*

# Glossary

**Aperture**
The opening in a lens that admits light. Except in very simple cameras, the size of the aperture can be varied to regulate the amount of light passing through the lens to the film.

**Available light**
The existing natural or artificial light, without the addition of photographic lighting. Usually the term refers to low light levels, for example at dusk.

**Backlighting**
A form of lighting in which the principal light source shines toward the camera and lights the subject from behind.

**Bounce flash**
A technique of softening the light from a flash source by directing it onto a ceiling, wall, board or similar reflective surface before it reaches the subject.

**Cropping**
Trimming an image along one or more of its edges to eliminate unnecessary parts, or framing a scene to leave out elements of the subject.

**Depth of field**
The zone of acceptable sharp focus in a photograph, extending in front of and behind the plane of the subject that is most precisely focused by the lens.

**Diffused light**
Light that has lost some of its intensity by being reflected or by passing through a translucent material.

**Exposure**
The total amount of light allowed to pass through a lens to the film, as controlled by both aperture size and shutter speed. The exposure selected must be tailored to the film's sensitivity to light, indicated by the film speed rating. Hence overexposure means that too much light has created a slide or print that is too pale. Conversely, underexposure means that too little light has resulted in a dark image.

**Film speed**
A film's sensitivity to light, rated numerically so that it can be matched to the camera's exposure controls. The two most commonly used scales, ASA (American Standards Association) and DIN (Deutsche Industrie Norm), have now been superseded by a new system known as ISO (International Standards Organization).

**Filter**
A thin sheet of glass, plastic or gelatin placed in front of the camera's lens to control or change the appearance of the picture. Some filters alter color or tone; others can, for example, cut out reflections or help reduce haze.

**Flash**
A very brief but intense burst of artificial light, used in photography as a supplement or alternative to any existing light in a scene.

**Focal length**
The distance, usually given in millimeters, between the optical center of a lens and the point at which rays of light from objects at infinity are brought to focus. In general, the greater the focal length of a lens, the smaller and more magnified the part of a scene it includes in the picture frame.

**Format**
The size or shape of a negative or print. The term usually refers to a particular film size, for example 35mm format, but is often used to distinguish between pictures that are upright (vertical or "portrait" format) or longitudinal (horizontal or "landscape" format).

**Golden section**
A proportion in which a line or rectangle is divided into two unequal parts in such a way that the ratio of the smaller to the larger part is equal to the ratio of the larger part to the whole, approximating numerically 5:8. Since antiquity, this proportion has been thought to possess inherent aesthetic value, and it is often used as a basis for deciding where to place the main point of interest in a picture.

**Grade**
A term used to describe the degree of contrast of papers used in black-and-white printing. A "hard" grade of paper gives contrasty prints; a "soft" grade gives a much gentler gradation of tones.

**Grain**
A granular texture that appears to some degree in all photographic images.

**Key**
A term describing the prevailing tone of a photograph. "High key" refers to a predominantly light image; "low key" refers to a predominantly dark one.

**Lens**
An optical device made of glass or other transparent material that forms images by bending and focusing rays of light. A normal lens produces an image that is close to the way the eye sees the world in terms of scale, angle of view and perspective. For most SLRs the normal lens has a focal length of about 50mm. A wide-angle lens (for example, 28mm) takes in a broader view of a scene than does a normal lens, and a telephoto lens (for example, 135mm) shows a smaller area on a larger scale. A zoom lens is variable in focal length. For example, in an 80mm – 200mm zoom lens, the focal length can be changed anywhere between the lower limit of 80mm and the upper limit of 200mm. With a zoom, a photographer can reduce or enlarge the scale of an image without throwing it out of focus.

**Photolamp**
A light bulb specially designed for photographic use. It is similar to a household bulb, but bigger and brighter.

**Rimlighting**
Lighting in which the subject appears outlined against a dark background. Usually the light source is above and behind the subject, but rimlit photographs can look quite different from conventional backlit images, in which the background is usually bright.

**Sidelighting**
A form of lighting in which light falls on the subject from one side. Sidelighting produces dramatic effects, casting long shadows while emphasizing texture and form.

**Thirds, rule of**
A simple compositional principle whereby the main point of interest of a scene is placed approximately one-third from one of the edges of the picture frame. The term "intersection of thirds" is used when the subject is centered on a point approximately one-third in from two adjacent edges.

**Tripod**
A three-legged camera support. The legs (usually collapsible) are hinged together at one end to a head to which the camera is attached.

**TTL**
An abbreviation for "through-the-lens," generally used to refer to exposure metering systems in which the light intensity is measured after passing through the camera lens.

**Vapor lamp**
A lamp containing a gas or vapor that glows with light when an electric current passes through it. Neon, sodium and mercury vapor lamps produce strongly colored light, but the light from some fluorescent tubes (a special kind of vapor lamp) more closely approximates daylight.

# Index

# Acknowledgments

**Picture Credits**

Abbreviations used are: t top; c center; b bottom; l left; r right.
Michael Freeman is abbreviated as MF.

**Cover** Pete Turner/Image Bank

**Title** Stephen Romney. **7** Brian Seed/Click/Chicago. **8** Alfonse Iseli. **9** Robin Bath. **10** Douglas Kirkland/Image Bank. **11** Steve Wall/Click/Chicago. **12/13** Kodak-Pathé. **14** Robin Bath. **14-15** Kodak-Pathé. **16-17** David Gallant. **18** l (box) MF, r Sepp Seitz/Woodfin Camp Associates. **19** tl Vautier/de Nanxe, tr Pete Turner/Image Bank, b Ernst Haas/Magnum. **20** MF. **21** John Sims. **22** Ian McKinnell. **23** t MF. b Alastair Black. **24** t Jerry Young, c Robin Laurance, b Neill Menneer. **25** Jerry Young. **26** l Kodak-Pathé, r Uli Butz. **27** l Steve Powell/All-Sport, r Ian McKinnell. **28** Mike Yamashita/Woodfin Camp Associates. **28-29** Neill Menneer. **29** l Robin Laurance, r (box) Ian McKinnell. **30** l Neill Menneer. **30-31** Hans Woolf/Image Bank. **31** Michelle Garrett. **32** t Alastair Black, b Harry Gruyaert/Magnum. **33** Pete Turner/Image Bank. **34** l Timothy Beddow, r Steve Powell/All-Sport. **34-35** Ernst Haas/Magnum. **36-37** Marcel Nauer. **38** Ian Berry/Magnum. **39** t MF, c John Garrett/Tony Stone Associates, b Jean-Paul Ferrero/Ardea London. **40** l Patricia Birdman, r Graeme Harris. **41** t MF, b Sergio Dorantes. **42** t Timothy Woodcock, b Mitchell Jadow. **43** Vautier/de Nanxe. **44** t Robert J Walcyak, b Vautier/de Nanxe. **44-45** Brain Seed/Click/Chicago. **46** t David Gallant, b Peter Riedwyl. **47** t Felix Aerberli, b Vautier/de Nanxe. **48** t Timothy Beddow, b John Garrett. **49** Richard Brook. **50** Alain Bardou. **51** Barry Lewis/Network. **52** t John Roberts, b John Veasey. **53** tl Linda Burgess, tr Ed Buziak, b Graeme Harris. **54** t Hans Woolf, b Anne Conway. **55** John Garrett. **56-57** Brian Seed/Click/Chicago. **57** t MF, b John Heseltine. **58** Neill Menneer. **59** Anne Conway. **60** Richard Haughton. **61** John Starr. **62** MF. **63** tl Ian Berry/Magnum, tr Uli Butz, b Mike Burgess. **64-65** Hans Wendler/Image Bank. **66-67** Jerry Young. **68-69** Linda Burgess. **70** Andreas Heumann. **71** Linda Burgess. **72** tl S & O Matthews, tr Graeme Harris, b Jürg Blatter. **73** Martin Elliott. **74** MF. **74-75** Heather Angel. **75** Jerry Young. **76** John Sims. **76-77** Dennis Stock/Magnum. **78** l G Boutin/Explorer, r Bruno Barbey/Magnum. **79** t Graeme Harris, b Kodak-Pathé. **80** David Whyte. **81** MF. **82-83** John Sims. **83** t Gerard Petremand, b Peter Mosimann. **84** t Vautier/de Nanxe, b John Sims. **85** MF. **86-87** John Cleare/Mountain Camera. **88** t Alfonse Iseli, b Anne Conway. **89** Jerry Young. **90-91** Jürg Blatter. **91** Forrest Smyth. **92** l Bob Croxford, r MF. **93** t David Gallant, b Robin Laurance. **94** t Michael Elliott Taylor, b Jürg Blatter. **95** Dick Scott-Stewart. **96** tr Bob Croxford, bl Erika Sulzar-Kleinemeier, br Robin Laurance. **97** MF. **98** Krishan Arora. **99** t Angelo Hornak, b Paul Keel. **100** l Graham Finlayson, r Alan Wrigley. **101** Graham Finlayson.

**Artists** Alun Jones, Andrew Popkiewicz

**Retouching** Roy Flooks

Kodak, Ektachrome, Kodachrome and Kodacolor are trademarks